D1027853

IMAGES
of America

MUSKOGEE

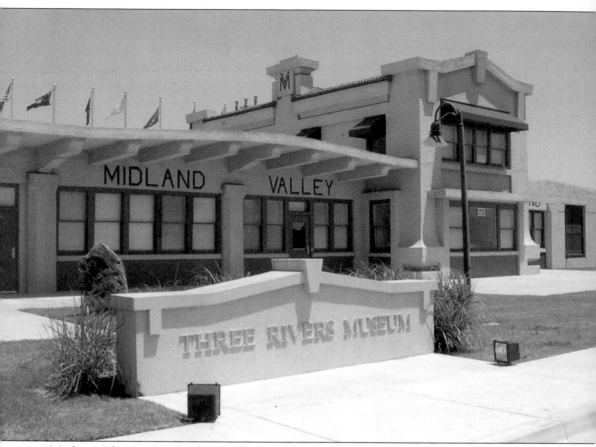

Muskogee's historic Midland Valley Depot was completely restored in 2000 for the establishment of the Three Rivers Museum of Muskogee. Today, the museum is a showcase for the history and culture of Muskogee and the surrounding area. (Courtesy Three Rivers Museum.)

ON THE COVER: This lively parade photograph from 1946 was taken on Broadway, looking west from just past Second Street. The parade grand marshal, Western movie star Monte Hale, is shown on horseback in white clothing being chased by children. In the far right background is the grand Severs Hotel and two buildings that no longer remain, the Indianola and the Flynn-Ames. (Courtesy Three Rivers Museum.)

IMAGES
of America
MUSKOGEE

Roger Bell

ARCADIA
PUBLISHING

Published by Arcadia Publishing
Charleston, South Carolina

Printed in the United States of America

Library of Congress Control Number: 2011931578

For all general information, please contact Arcadia Publishing:
Telephone 843-853-2070
Fax 843-853-0044
E-mail sales@arcadiapublishing.com
For customer service and orders:
Toll-Free 1-888-313-2665

Visit us on the Internet at www.arcadiapublishing.com

This book is dedicated to all persons who cherish the history of Muskogee and to those who continue to work to preserve its fascinating history for future generations.

CONTENTS

ACKNOWLEDGMENTS

The Three Rivers Museum of Muskogee was first formulated, as a dream, in 1988 by a dedicated group of volunteers led by Dorothy Beam Ball. This group was determined to create a local and regional historical museum to help preserve the rich and diverse history of Muskogee and the surrounding Three Rivers area of Eastern Oklahoma. Thirteen years later, after countless roadblocks were overcome, the Three Rivers Museum opened in 2001 in the restored historic Midland Valley Depot. Today, the museum is an important and active part of the Muskogee community, and the dream of a place to assist in the preservation of the history of Muskogee has been realized.

Many persons were responsible for the creation of the museum and its ongoing operations; without them, this book would not have been possible. Additionally, all donors of images to the Three Rivers Museum should be recognized and applauded for their contributions and valuable support of the preservation of history. All images in this book appear courtesy of the Three Rivers Museum unless otherwise noted. Further information on the museum can be obtained at www.3riversmuseum.com.

Special thanks go to Three Rivers Museum Executive Director Sue Tolbert and volunteer Barbara Downs for their gracious help and support in the completion of this book. Wally Waits, Linda Moore, Jonita Mullins, and Karen Wagner provided additional historical research and assistance.

I also wish to acknowledge the late Muskogee historian C.W. "Dub" West, who kept the history of Muskogee alive for many years. I received a copy of his book, *Muscogee, I.T.*, in 1976 while in grade school and the book and others written by Dub were extremely important in igniting a passion and interest in the history of Muskogee in me at an early age. My parents, Robert and Louise Bell, also deserve special thanks for kindling my love of history over the years and always supporting my efforts.

Finally, and most importantly, I sincerely appreciated the help and patience of my immediate family while completing this book. My wife, Tammy, and children, Rachel and Russell, were extremely supportive of my effort and important to its completion.

INTRODUCTION

Muskogee was born of humble beginnings on New Year's Day in 1872, when the Missouri, Kansas & Texas Railway (MK&T, aka the Katy) track crew reached a point across the Arkansas River and determined that a terminus needed to be established at that location. A tent city was quickly developed on the treeless prairie and Muskogee, Indian Territory was born.

Muskogee was truly an American western frontier town during its formation. It is said that almost a dozen murders were recorded over the first few months of its existence. Gamblers, whiskey peddlers, fugitives, and other outlaws were drawn to the settlement, which had no semblance of law and order.

The railroad terminus attracted a few brave merchants and other businessmen to the settlement. Growth was slow, though, and a severe drought in 1874 made conditions difficult in the town.

In 1875, the Union Indian Agency was built upon a hill (later called Agency Hill) about three miles west of Muskogee. This action was important to the early growth of Muskogee, and within a year, the agency moved to Muskogee to be closer to the town and the railroad. Additionally, an Indian Fair was established at this time by leading men of the Cherokee and Creek tribes. It brought additional interest in Muskogee to persons in Indian Territory. The population of the town continued to grow, reaching 400 residents in 1878.

In 1885, Almon C. Bacone moved his Indian University (later Bacone College) by wagons from Tahlequah to a site near Muskogee to be closer to the Indian Agency. This promoted additional interest in Muskogee; however, the town was still known to be a dangerous place with limited organization and structure. In 1887, the city suffered its first major fire and most of the crude wooden structures in the town were destroyed. The town pioneers soon rebuilt and reestablished the town. The *Muskogee Phoenix* newspaper was established at this time and was named for the "resurgent spirit of the community" rising from the aftermath of the fire.

Then, in 1889, Muskogee was selected as the site for the first US federal court in Indian Territory. The resulting growth was almost immediate. Soon, lawyers, government employees, and additional businessmen moved to the town. Further growth occurred with the establishment of the Dawes Commission in Muskogee in 1894. The commission was established to begin negotiations and oversee allotment of Indian lands.

The federal Curtis Act was passed in 1898 and allowed for the allotment process of lands in Indian Territory to begin. Soon after its passage, a petition bearing 240 signatures was filed to incorporate the City of Muskogee. The city's growth was continuing and Muskogee was fast becoming the most important city in the territory.

On February 23, 1899, Muskogee received a devastating blow when a large fire struck again and consumed the majority of the central business district. Muskogee citizens quickly rallied together and entered the new century determined to rebuild "bigger and better."

As the new century started, there were growing expectations for statehood for the Indian Territory and Muskogee was promoted as becoming the "star of the new star." Additional railroad

development was established in the community, promoted by new Muskogee resident Charles N. Haskell. The African American community in the town developed its own thriving business district and several large conventions came to the city.

A constitutional convention to form a separate state of Indian Territory was held in Muskogee in August 1905 and Muskogee was expected to become the capitol. Separate statehood for Indian Territory found little favor in Washington, though, and the state of Oklahoma was formed combining Oklahoma and Indian Territories into one state. Oklahoma became the 46th state on November 16, 1907, and Muskogee's Charles Haskell was elected as the first governor.

At that time, Muskogee had grown to become the second largest city in Oklahoma. Soon after statehood, large skyscrapers were built in the city and the population surged to above 30,000 residents. Muskogee was thought to be on its way to becoming a major metropolitan city.

The discoveries of significant oil fields in other areas of the state nearer to Tulseytown, or Tulsa, soon began to slow growth. Muskogee's railroad lines were not able to provide the important connections to the oil field locations needed at the time to establish commercial activity. Tulsa started a significant period of growth, with much of it at the expense of Muskogee.

By the 1920s, Muskogee entered into an era of becoming a working-class community. The VA Hospital was established in 1922 and several businesses, such as the Muskogee Iron Works and Griffin Grocery Company, became further established and brought jobs to the area. Growth had slowed considerably, but the city now contained over 40,000 people.

Like other communities across the country, the Great Depression significantly impacted Muskogee during the late 1920s and 1930s. Many farmers suffered greatly from the low crop prices and several community banks were pushed to the edge. During this time, Muskogee's City Municipal Building was built and the area around Agency Hill, which had been renamed Honor Heights Park, was further developed and transformed into a garden spot for the city.

The outbreak of World War II was a jolt to Muskogee, as it was to the nation. Muskogee received some important news when it was announced that a military training base was to be established in nearby Braggs, Oklahoma. The building of Camp Gruber and a flight school at Muskogee's Hatbox Field airport were economic boosts to the town and the city was alive with activity.

After the war and into the 1950s, Muskogee saw some needed industrial growth and expansion. The Muskogee Industrial Foundation was successful in luring several companies to the area, including the Brockway and Corning Glass factories. It also helped at the start of the Bush Canning Company and helped local entrepreneurs such as O.W. Coburn, who established Coburn Manufacturing. Muskogee's downtown business district also continued to be a hub of retail activity in the area.

In 1967, Muskogee established the first Azalea Festival in Honor Heights Park. The festival was an instant success and now attracts thousands of visitors to the community each year. A few years later, Muskogee was catapulted into the national spotlight when country music star Merle Haggard released "Okie from Muskogee." The song was written as a satire, but placed nationwide attention on the community, and Haggard performed a concert at Muskogee's new Civic Assembly Center during the time.

After many years of effort, the McClellan-Kerr River Navigation System was opened along the nearby Arkansas River in 1971 and Muskogee was established as an inlet port, which spurred further industrial growth and development to the community. In 1976, the Fort Howard Company began construction of a paper making and paper converting plant in Muskogee, which soon after became the largest employer in town.

Muskogee has a rich and exciting history and has progressed from a wide open frontier town to a thriving and culturally diverse community. The images that you are about to see provide a window into the past. It is hoped that the reader will enjoy this look back through time.

One

FRONTIER MUSKOGEE
1872–1899

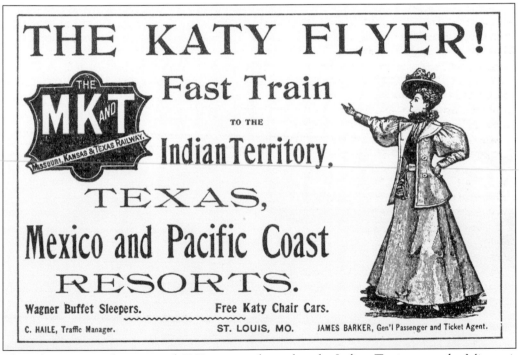

This advertisement from around 1880 promoted travel to the Indian Territory on the Missouri, Kansas & Texas (MK&T, or Katy) Railway. The railroad was the first to enter the Indian Territory in 1870. However, the area where Muskogee was formed was not originally in the plans for the railroad. Construction was first planned directly through the Cherokee Nation in Indian Territory and was to include a terminus at Fort Gibson. Cherokee leadership, however, was not receptive to some of the railroad's plans and the railroad subsequently diverted construction through the more welcoming Creek (or Muscogee) tribal lands. On New Year's Day in 1872, the Katy crossed the Arkansas River into the Creek Nation and a terminus was formed and named "Muscogee Station." A crude settlement was soon established and Muskogee was born.

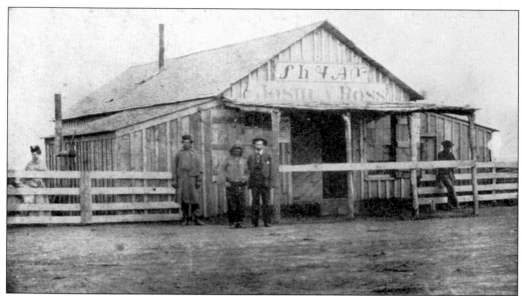

This store was one of the earliest established in Muskogee, in about 1874. It was owned and operated by resident Joshua Ross and stood along the Texas Road (now Cherokee Street) at Broadway, facing the railroad tracks. The Joshua Ross name is shown on the store, along with the Ross name spelled out in the Cherokee (or Sequoyah) alphabet.

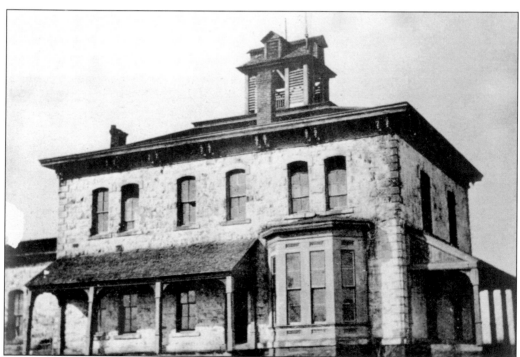

In 1875, the Union Indian Agency was built upon Agency Hill (now Honor Heights). The building was only used until 1876, as the location proved to be too far removed from Muskogee and the agency was moved into town. It has subsequently been used for a variety of things, including an orphanage, a tearoom, a dance hall, and currently as the Five Civilized Tribes Museum.

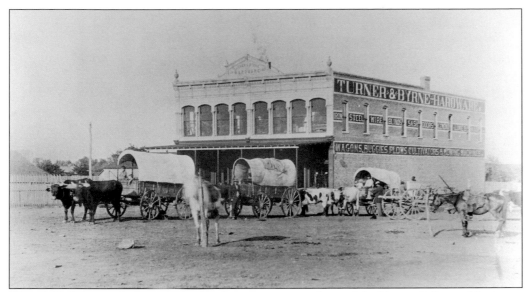

This early photograph shows covered wagons crossing in front of the Turner & Byrne Hardware Store on Main Street. This store was established in 1882 when Clarence Turner and Patrick Byrne (later the first mayor of Muskogee) purchased a store from J.S. Atkinson and began building one of the largest hardware businesses in the southwestern United States.

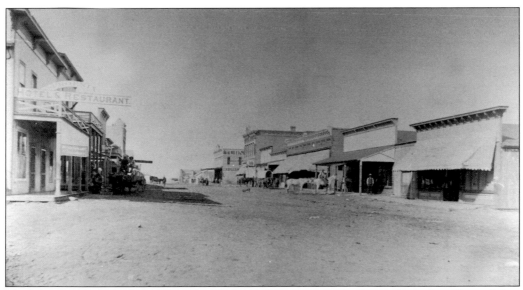

Muskogee in its early days was a true Western frontier town, with wooden sidewalks and dirt streets. This c. 1888 photograph was taken from Okmulgee Street looking north onto Main Street. The Turner & Byrne Hardware Store can be seen in the back at far right, with the Patterson Mercantile store just to the south.

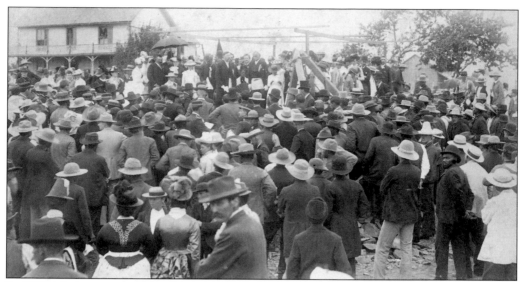

In 1889, Muskogee was selected to be the site of the first federal court in Indian Territory. This picture was taken at the ceremony for the laying of the cornerstone for the federal courthouse, which was built on the southwest corner of Second and Court Streets. Judge James M. Shackelford (rear center), from Indiana, was the first judge of the court. After the ceremony was over, a large barbecue feast was shared by all.

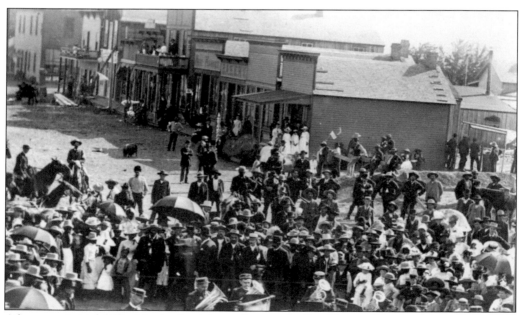

After some initial difficulties in obtaining a charter, the First National Bank of Muskogee opened for business in 1890. The bank was the first to be established in Indian Territory and what is now the state of Oklahoma. This image shows the celebration ceremony for the laying of the cornerstone for this building, the Severs Block, on Main Street at Broadway.

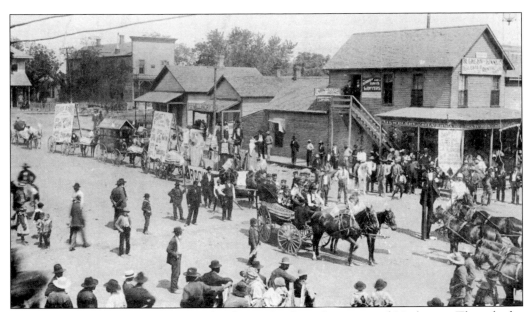

This early photograph shows a parade of some kind on the streets of Muskogee. Though the location is not fully established, it is believed to be at Third Street (Lake Street at the time) and Broadway (Agency Street at the time). The business signs confirm the location as Muskogee.

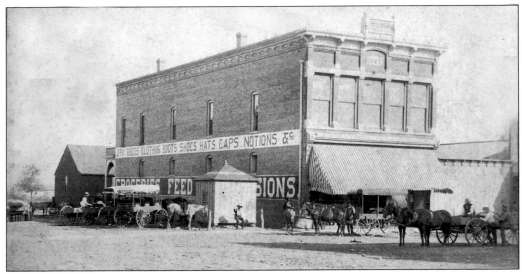

James A. Patterson was one of the earliest merchants in Muskogee and first established a store in 1872, soon after Muskogee's formation. The original wood frame building he built at that time was destroyed in a large fire in 1887 and the store pictured here was built afterward (note the 1887 date on the building). The business was located on the southeast corner of Main Street and Broadway.

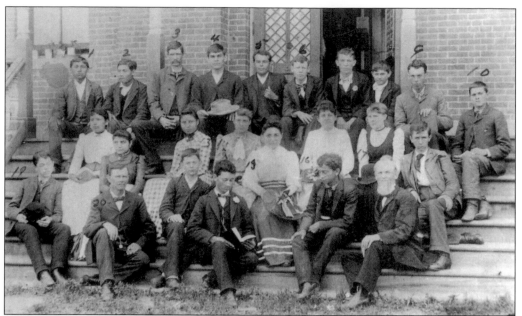

In June 1885, "Indian University" moved its entire student body by wagons from Tahlequah to a location closer to the Indian Agency in Muskogee. This picture from 1891 shows the advanced students with founder Almon C. Bacone (first row, far right). Reading the book in the center is student Alex Posey, who became poet laureate of the Creek Nation before his untimely drowning in 1908 while crossing the Oktahuche River, also known as the North Canadian River, near Eufaula.

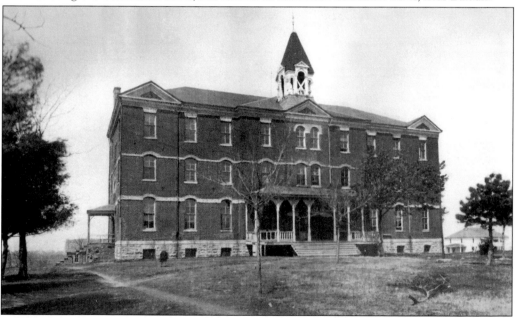

"Old Rock," or Rockefeller Hall, was the first building on the campus of Indian Baptist University (changed to Bacone University in 1910). Laura Spellman, one of the teachers, married John D. Rockefeller Sr., and upon a visit by Bacone to their home in Cleveland, Ohio, Rockefeller pledged $10,000 to fund the construction of this building, which was named for him. The building was last used in 1938 and was later demolished.

In March 1878, the Creek Nation gave local Methodists permission to build a church in Muskogee. This church, often referred to as the "Rock Church," was located at Cherokee and East Okmulgee Streets, along the Texas Road. The building was not only used by the Methodist members of the community, but also by other denominations before they built their own buildings. The church building burned in 1903.

Grace Episcopal Mission (later Grace Episcopal Church) was organized in Muskogee in 1893 and met at various locations, including the federal courthouse, during its first years. This small frame building became the first permanent home of the church on Easter Sunday, April 14, 1895. This structure was on the 200 block of South Fourth Street.

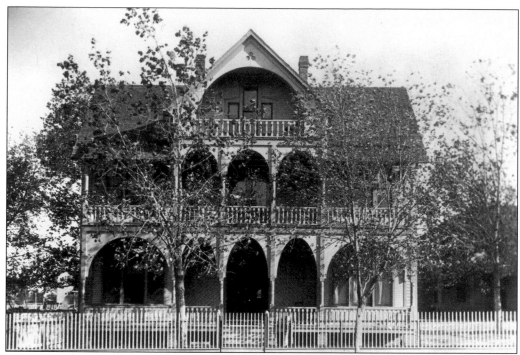

Muskogee's early Presbyterian Mission was so successful that it became necessary to expand its education activities. The Minerva Home was built after funding was obtained from a wealthy cousin of Alice Robertson and named in memory of her sister. The home was established as a boarding school for girls and was located facing Okmulgee Street near Second Street. The school later became Henry Kendall College and eventually the University of Tulsa.

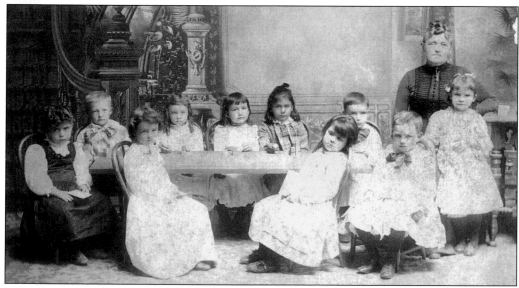

A kindergarten class at the Minerva Home is pictured here. The school's goal, according to statements in area newspapers, was "the elevation of Indian womanhood, accomplished through a course of study focusing on cooking, sewing, order, and cleanliness." A year's tuition cost $100.

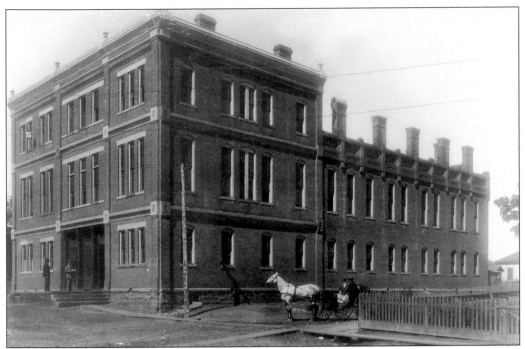

The first federal courthouse in Indian Territory was built on the southwest corner of Second and Court Streets (now the site of the Haskell Building). The building was primarily funded through the generosity of merchant Clarence Turner. It was the center of law enforcement in Indian Territory for many years, and some of the famous law enforcement officers of the era were headquartered here.

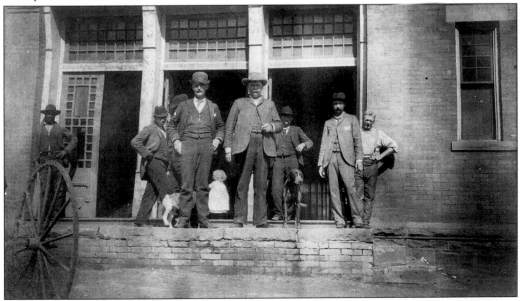

US Deputy Marshal David Adams (front center, with wide-brimmed hat) and other deputies and staff are shown here in front of the federal courthouse in the mid-1890s. Adams was involved in the capture of several outlaws in the area. More US deputy marshals were reported killed within a 50-mile radius of Muskogee than in any such location in the American West.

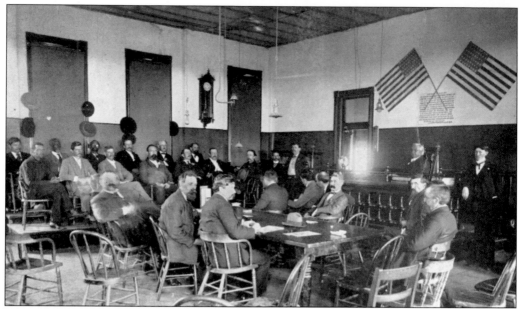

John R. Thomas Sr. (shown above in courtroom) was appointed a federal judge in Indian Territory in 1897 by his friend, Pres. William McKinley. Thomas judged many important trials, including the trials of K.B. Brooks and Henry Whitefield, who were both sentenced and hanged on the gallows in Muskogee in 1898. Later, while in public practice, Thomas was killed in the first prison riot at the Oklahoma State Penitentiary in McAlester in 1914.

Judge Thomas built this farmhouse on the open prairie on the western outskirts of town after purchasing the land from Creek chief Pleasant Porter. At the time of construction, there were no other buildings in the area except a nearby abandoned log cabin. Today, the home is located at Fifteenth and Okmulgee Streets and operates as the Thomas-Foreman historic home. It is open to the public for tours.

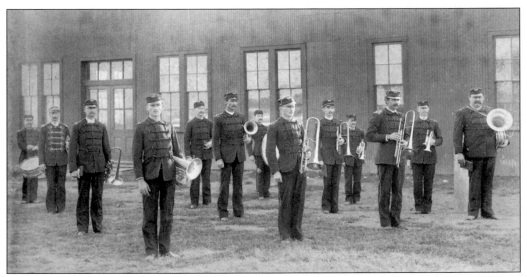

William Maddin came to Muskogee in 1884 to construct the Minerva Home. He built many of the early homes and buildings in Muskogee and then entered the hardware business in the 1890s at Main and Court Streets. One of his contributions to the town was the organization of the Maddin Mechanics Band, which is pictured here, with Maddin on the far right.

The impressive Hotel Adams was built in 1892 and was a combination hotel and depot for the Katy railroad. The structure was located along the west side of the MK&T Railway tracks at Broadway, on the site where the Katy depot was later built. This rare photo of the hotel was taken in 1898.

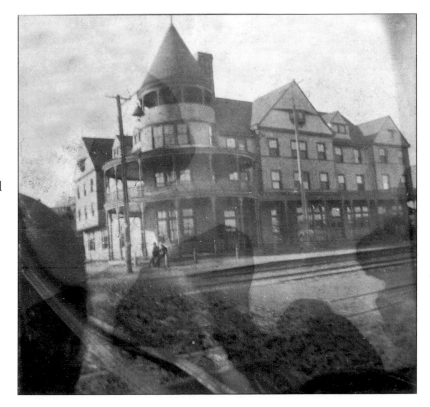

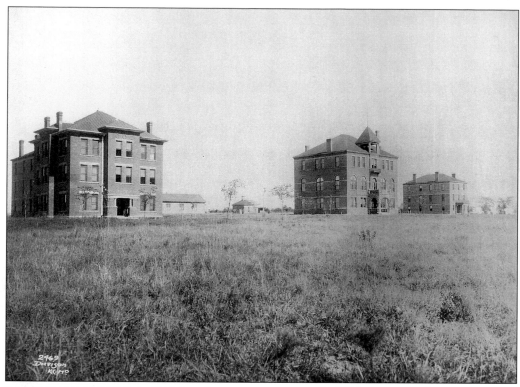

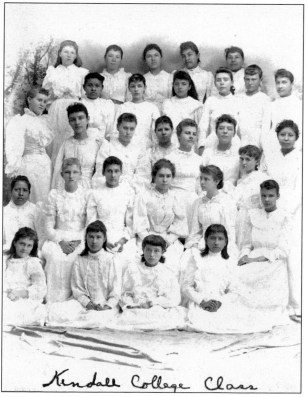

Kendall College Class

In 1894, the curriculum at the Minerva School was expanded to include college courses and male students. The name was changed to Henry Kendall College and it moved to a larger campus located between Boston and Elgin, between Twelfth and Fourteenth Streets. There were four buildings on campus, including a main building, a girls' dormitory, a boys' dormitory, and the president's home, which currently remains as a residence on Kendall Boulevard.

Kendall students were offered seven years of course work—three years of prep school and four years of college credit. By 1906, the school had declining enrollment and the campus land was becoming more valuable for residential development. The town of Tulsa (population 7,000) enticed the school with an offer to move, and it accepted. The school became the University of Tulsa in 1921.

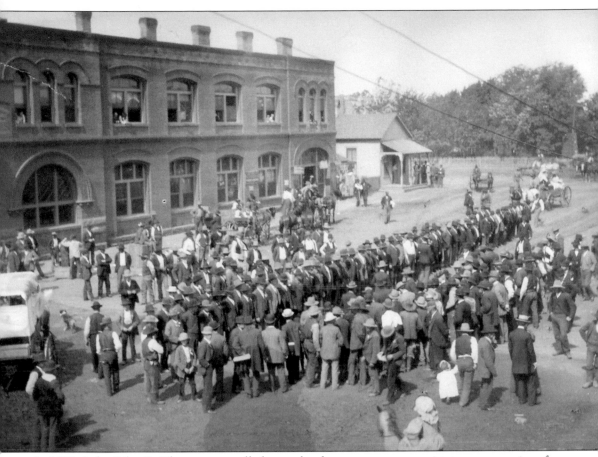

In 1898, Judge John R. Thomas was called upon by the government to raise two companies of men to be sent to Cuba for the Spanish-American War. Two hundred recruits from Muskogee, including the judge's son John Thomas Jr., were subsequently sworn in on May 12, 1898, and became "Rough Riders." This photograph shows the recruits being assembled at the corner of Broadway and Main Street in front of the Severs Block building. Many of the recruits were students at Henry Kendall College and one of their outstanding students, Milo Hendrix, was a casualty of the Battle of San Juan Hill.

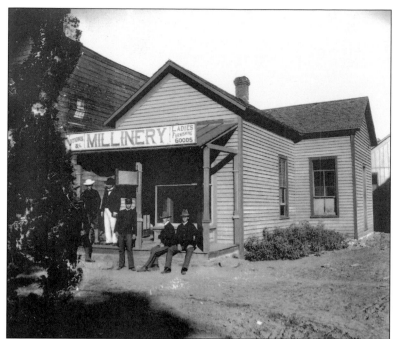

Several Rough Riders are shown here after their return from Cuba in front of a millinery (hat store). This store was previously used as a recruiting office for the Rough Riders. The building was also used as the polling place for the first city elections in 1898, which ushered in the first mayor, Patrick Byrne, and the first city council.

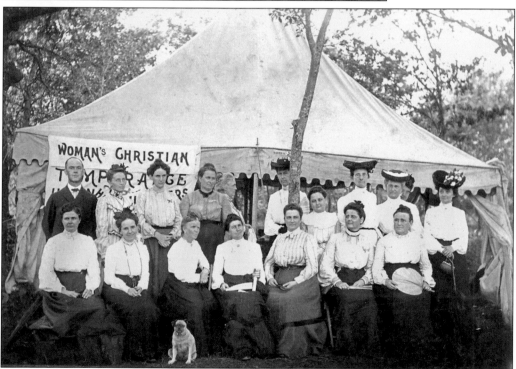

The Women's Christian Temperance Union was organized in Muskogee by Laura Harsha, the wife of merchant William S. Harsha. Laura Harsha was a strong advocate of temperance and was known to regularly make the rounds in Muskogee, going from store to store to check if anything more intoxicating than beer was being sold. She is pictured here fourth from left in the front row.

One of the most influential pioneers in early Muskogee was Clarence Turner. Turner first came to Muskogee in 1882 and his Turner Hardware Store was once one of the largest retail businesses south of St. Louis. He was an organizer of the First National Bank, helped finance Henry Kendall College, and built the first opera house. Turner also helped finance the education of many Muskogee children; it was a regular occurrence to see orphaned children living in his home.

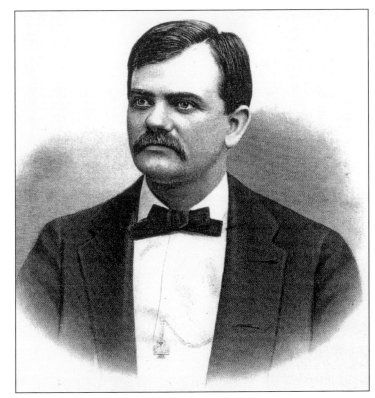

The Turner Hardware Store, pictured here in 1898, was located on Main Street between Broadway and Court Street and was the primary retail establishment in Indian Territory for many years. The store had a full lumberyard, and the elegant Turner Opera House, which seated up to 700 people, was located on the upper floor. Turner lost stores twice to devastating fires, in 1887 and 1899, and rebuilt his stores both times.

While some of the African Americans in the area were "freedmen" (former slaves of the Five Civilized Tribes), others were drawn to the area as a place for new opportunity and prosperity. Their inclusion, along with the Native Americans and white settlers, led to Muskogee becoming one of the most diverse racial areas in the American West. This image shows an African American farmer looking over plantings of corn near Muskogee.

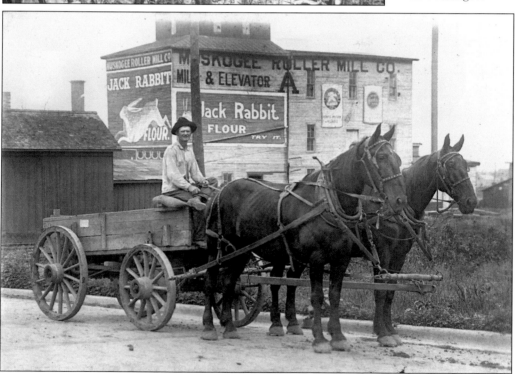

A wagon rides down Main Street with the Muskogee Roller Mill in the background. The mill (the first in Indian Territory) was located at the juncture of Fondulac (now Martin Luther King) and Mill Streets. The Jack Rabbit flour advertised in the background was a product of the mill.

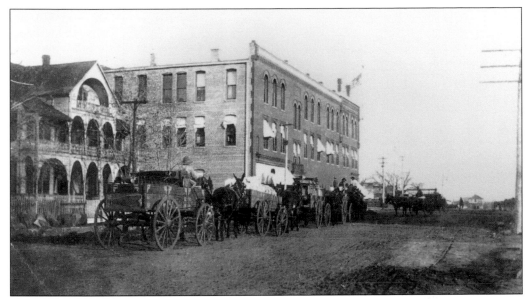

In March 1893, the US Congress formed a three-man commission, named the "Dawes Commission" after its chairman Henry Dawes, to negotiate new land treaties with the Five Civilized Tribes. Muskogee became the headquarters of the Dawes Commission and a building was constructed for the commission at Second and Okmulgee Streets. Pictured here are wagons loaded and ready to travel and seek out tribal members in the area. (Courtesy of the Oklahoma Historical Society.)

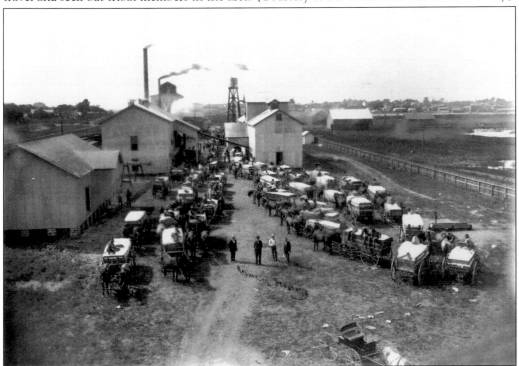

Cotton was certainly the primary agricultural crop in the Indian Territory. It was a common sight to see the streets packed with wagons carrying cotton to the gins in downtown Muskogee. This cotton gin is believed to be the Harsha and Spaulding gin.

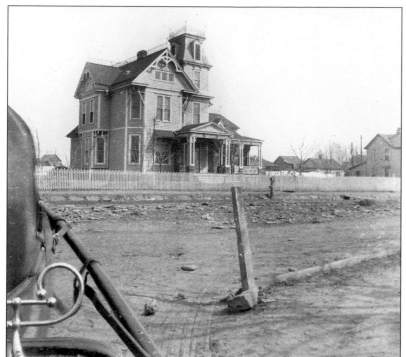

Dr. Frances B. Fite came to Muskogee in 1889 after spending two years as an assistant to prominent surgeon Dr. John Wyeth of New York City. Fite, a pioneer in the belief that infection was caused by germs, brought to Indian Territory the latest in medicine. His house (pictured here) was located on the corner of Fourth Street and Broadway and was one of the finest in the territory.

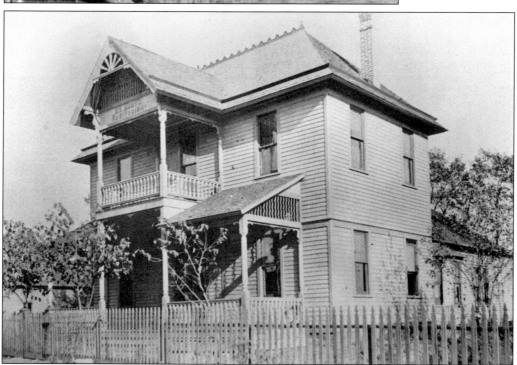

Dr. Fite established the first hospital in Muskogee and Indian Territory at 212 South Main Street in 1893. It was originally called St. Mary's, but the name was later changed to Martha Robb in honor of the wife of close friend Andrew W. Robb. Fite was first in the territory to have x-ray equipment, which was first used on outlaw Al Jennings after his capture by lawman Bud Ledbetter in 1898.

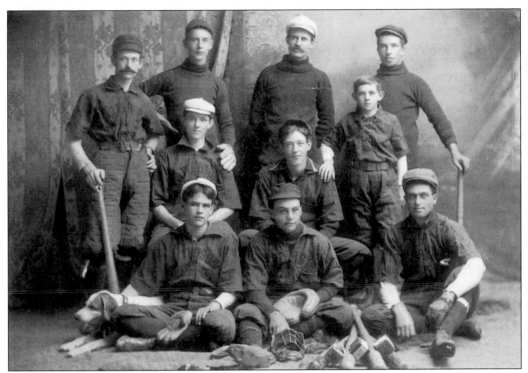

Baseball was a popular pastime in the early days of Muskogee. Ballgames were regularly played on an empty parcel of land near Fifth and Boston Streets, named Owen Field because of its proximity to the residence of Robert L. Owen. This land was later developed into the site for Athletic Park. Pictured here is the Patterson Mercantile team, which consisted of employees of the business.

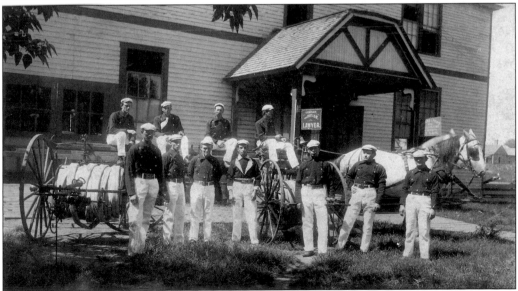

The first organized fire department in Muskogee was established around 1895. Pictured here is the fire department from around 1898. It was staffed by volunteer firemen with limited equipment. The horses were kept at a livery barn, separate from the fire equipment. Muskogee suffered a major fire in 1887, but in the last year of the century, another fire would cause even more damage.

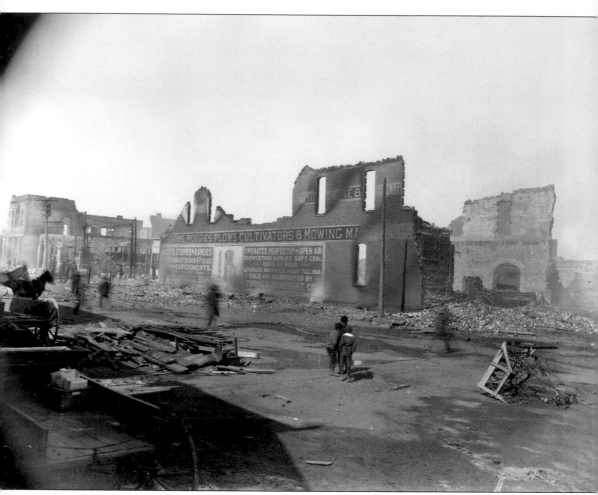

On a bitterly cold evening on February 23, 1899, a devastating fire consumed a large portion of Muskogee's core downtown area. The fire is believed to have begun at a tailoring and cleaning plant on Second Street, when a worker poured kerosene over some coals to build a fire. The fire spread rapidly over several blocks and soon destroyed almost half of the business part of town. Miraculously, no deaths were reported and the only serious injuries were to some of the firefighters who tried in vain to fight the blaze. The temperature at the time was said to be below zero, making it an almost intolerable event for the ill-equipped firemen. The largest loss was to Clarence Turner, estimated at more than $200,000. After the fire, members of the community are said to have gathered together at the intersection of Second and Okmulgee Streets and, amongst the cries, pledged to build back bigger and better than before.

Two

STAR OF THE NEW STAR
1900–1909

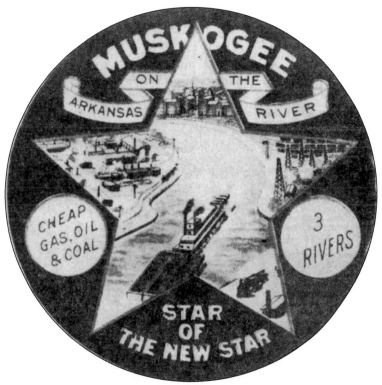

After the fire of 1899, Muskogee entered a phase of substantial growth and development. The city grew from a population of just over 4,000 in 1900 to well over 25,000 by 1910 and was the second largest city in the new state of Oklahoma at that time. The city was aided by increasing railroad development, the discovery of oil, and the promise of transportation on the nearby Arkansas River. Entrepreneurs, developers, oilmen, and other businessmen were drawn to Muskogee from across the United States. The city hosted many conventions during this time and numerous important entertainers and celebrities visited the city. Muskogee was poised to become a major metropolitan city. This promotional seal from the early 1900s shows Muskogee as the "Star of the New Star," which was a reference to pending statehood, and highlights resources available to potential investors.

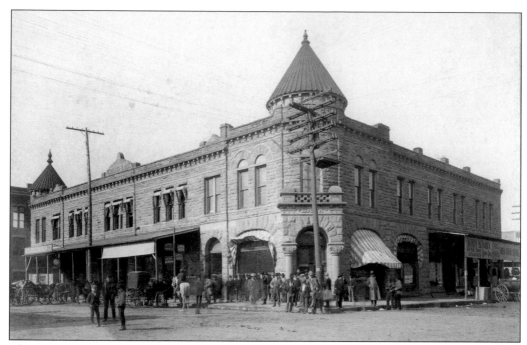

The original English Block (named for Muskogee businessman A.Z. English) was destroyed in the fire of 1899 and was subsequently rebuilt in grand style. This c. 1903 photograph shows the second English Block, which was located on the north side of Broadway, from Main to Second Streets (now a parking garage). The corner area was an early home of Commercial Bank.

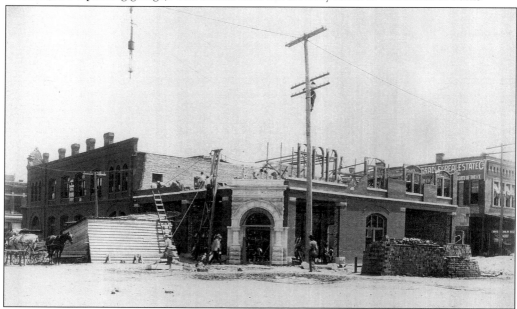

The Severs Block was one of the few buildings in the core downtown area that suffered minimal damage in the fire of 1899. In 1903, the building (shown here during construction) was extended further down Broadway to Second Street. The upstairs of this building was a center for cotton exchange activity in Muskogee for many years. This building has survived several fires, including a recent one in 2006.

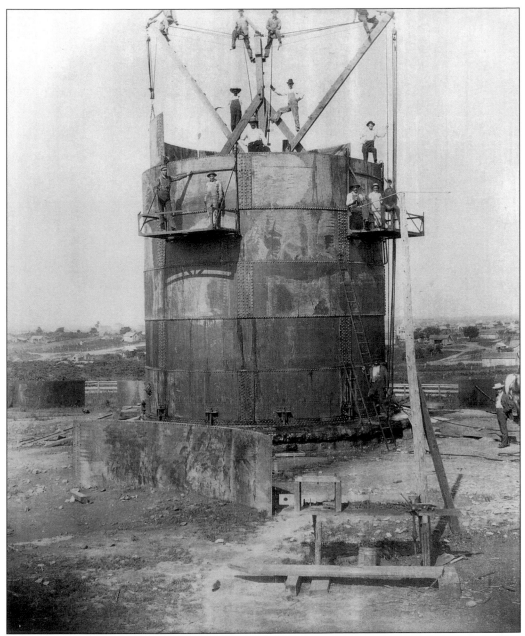

After the fire of 1899, the city made plans to create a better water system for Muskogee. In May 1903, the city council approved the purchase of 200 water meters, water lines, and material to build a standpipe for the supply of water. This image shows construction in progress on the standpipe in late 1903. The standpipe water system was the main water system for the city until 1912, when it was replaced by the reservoir on Agency Hill (Honor Heights). The standpipe was later dismantled and sold to the city of Ada, Oklahoma, in 1917 for $10,000. Tower Hill was named for the standpipe and is near the present-day location of Elliott Park.

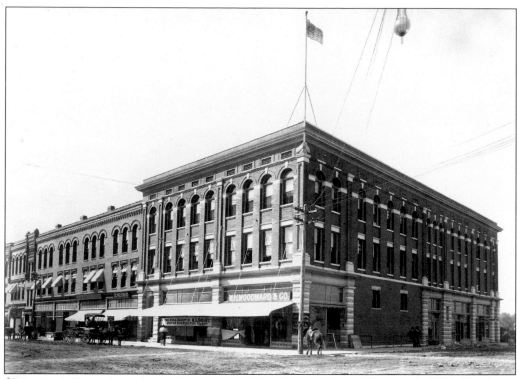

This c. 1904 picture shows the southwest corner of Broadway and Second Streets. The W.H. Woodward Dry Goods store can be seen in the corner of the Homestead Building. A little farther south, at left, one can see the J.C. Welch Clothing Store, which was owned by the builder of the grand Welch Mansion at Fourteenth and Okmulgee Streets. The Dawes Commission building is at far left.

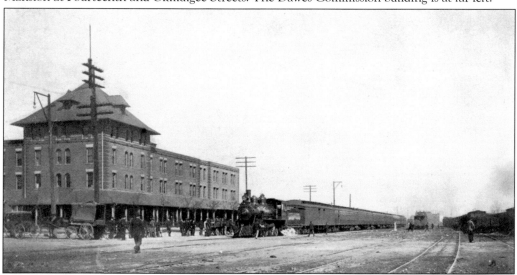

The fire of 1899 destroyed the former Adams Hotel and depot that was used by the MK&T railroad. Soon afterward, the railroad began work on a modern depot, which was completed at the tracks on the north side of Broadway. The depot originally housed a hotel and had a periodical stand in the front, near Broadway. The building remained in Muskogee until it was demolished in June 1966.

This picture shows the 1904 Bacone College football team. Team captain Patrick Hurley is holding the football. Hurley graduated in 1905 and later had a long and distinguished career serving as the US secretary of state under President Hoover; he was also Pres. Franklin D. Roosevelt's ambassador to China.

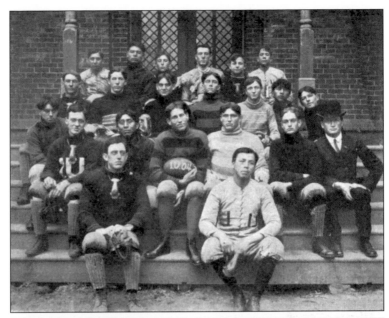

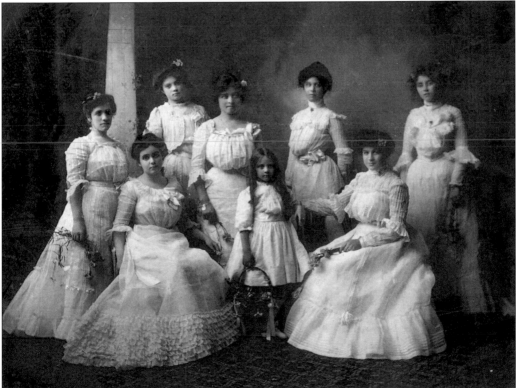

The bridal party for the wedding of Dannie Ross and Bates B. Burnett is shown here. The wedding was held on June 17, 1903, in the First Presbyterian Church. Alice Robertson was in charge of the wedding and this photograph was taken in her portrait studio. The following year, Robertson was named postmaster of Muskogee by Theodore Roosevelt, whom she had befriended at a speaking engagement in New York in 1891.

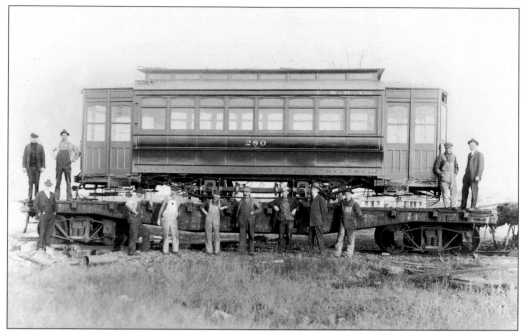

Muskogee's first trolley cars are shown here arriving by train. The first run of cars on the Muskogee Electric Traction Company routes occurred on March 15, 1905. The *Muskogee Daily Phoenix* heralded the day as a "new era for the city." It further commented that "Muskogee had now passed from the ranks of an overgrown walking town to the ranks of a metropolitan rapid transit city."

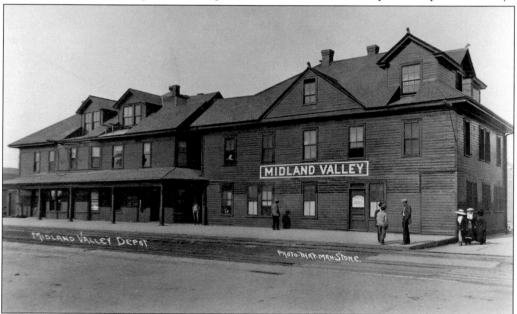

The original Midland Valley Depot was completed in July 1904, only a few months after the establishment of the railroad in Indian Territory. The wooden frame building was located between Second and Third Streets on Elgin Street. This building served as the passenger depot and railroad headquarters. The depot was replaced in 1917 with a stone-and-brick building that now houses the Three Rivers Museum.

34

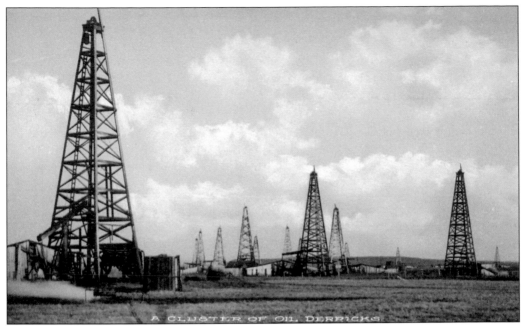

By 1903, oil speculators began to invade Muskogee and within a few years the area just to the south was filled with rows of derricks and oil equipment. J. Paul Getty even had a well in Muskogee, and many early oil drillers got their initial training in the Muskogee wells. Over time, Muskogee wells proved to be shallow, and eventually speculators left the area for greater discoveries closer to Tulsa.

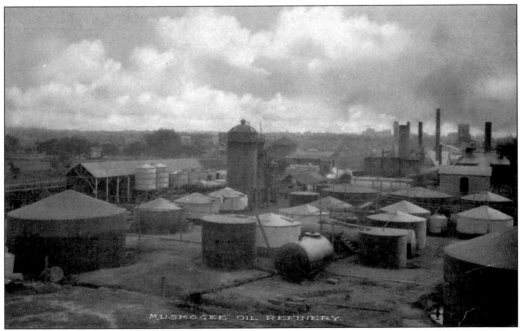

In 1905, Muskogee became the site of Oklahoma's first oil refinery. A historical marker recognizing this fact now resides along Highway 69 to the south of Muskogee. The plant produced kerosene, lubricating oil, and industrial fuel.

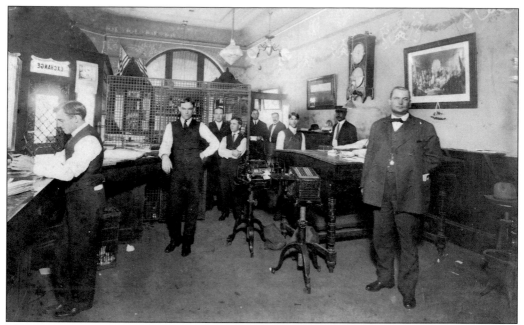

The First National Bank of Muskogee was established in 1890—the first bank in Indian Territory. The first location for the bank was in the Severs Block on the southwest corner of Main Street and Broadway. This interior picture of the bank in 1905 shows the employees at work and includes a young Louis W. Duncan (second from left) who later left to become the president of rival Commercial Bank of Muskogee.

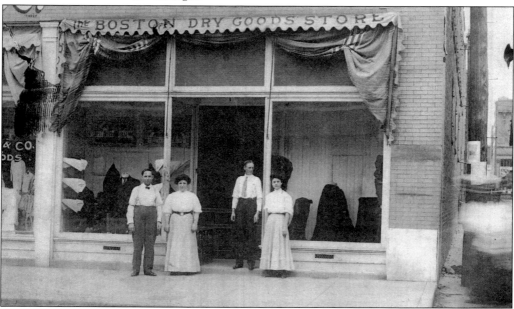

Established in 1905 by Harry Kirschner, the Boston Dry Goods Store was located at 216 West Okmulgee Street. Pictured here are, from left to right, Harry Kirschner, Sarah Kirschner, salesman William R. Sampson, and Ila Sampson. Kirschner was responsible for the first Jewish service in Muskogee, held in the same year. The Kirschners left the mercantile business in the 1920s and successfully entered the oil and real estate businesses.

During the early part of the 20th century, South Second Street developed into a center for African American business and was a vibrant part of Muskogee. The Jones Block building was built in 1904 at 200 South Second Street. At this time, the building included the Martin Café and Restaurant, lawyers' offices, and a bath facility. Later, the store housed the Muskogee Colored Library and the popular Elliott's Clothing Store.

In 1905, the *Muskogee Phoenix* announced the completion of a "big five-story skyscraper," the Indianola Building, built by Charles N. Haskell on the northwest corner of Third Street and Broadway. The Muskogee National Bank occupied the first floor at the time of this photograph. This building later had the top three stories taken off during a renovation by Phoenix Savings and Loan. In the distance, one can see the home of Francis B. Fite, which was one block west.

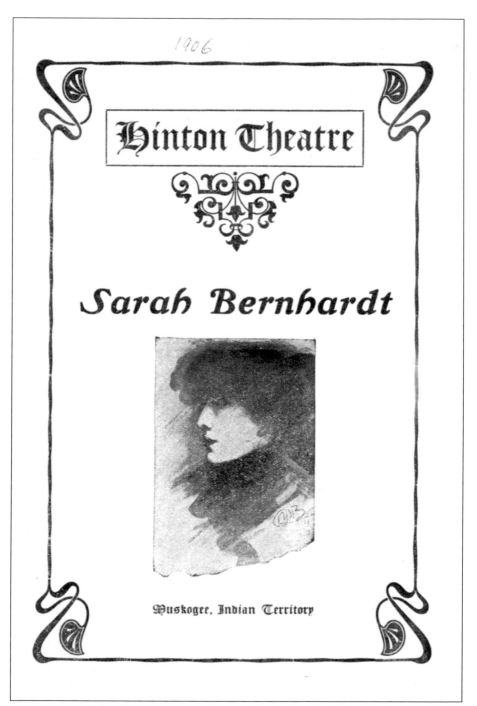

1906

Hinton Theatre

Sarah Bernhardt

Muskogee, Indian Territory

This program cover is for the appearance of actress Sarah Bernhardt in Muskogee at the Hinton Theatre (at Second and Court Streets) on April 3, 1906. Known throughout the world as "The Divine Sarah," Bernhardt was widely considered the greatest female actress of her time. The play performed at the Hinton on this evening was *La Dame aux Camelias*, which was a popular French play that she often starred in. Her performance was called "superb" in the *Muskogee Phoenix* and was a major event for the city.

In 1904, investor G.H. Johnson agreed to build the Hinton Theatre at Third and Court Streets. In order to attract the venture, Muskogee citizens agreed to fill the 1,000-seat theater on opening night at a cost of $10 a seat. The formal opening was held on December 9, 1905, with a production of *Babes in Toyland*. The newspaper account of the performance described the event as "dazzling" and "brilliant."

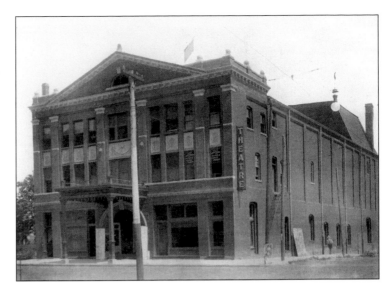

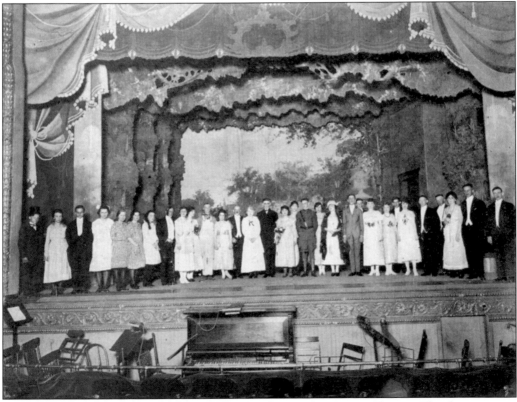

Pictured here is the cast of *Of Mice and Men* on stage at the Hinton Theatre. The theater was a showplace for Muskogee, and such notables as Enrico Caruso, Maude Adams, Al Jolson, William Jennings Bryan, William Howard Taft, Helen Keller, Will Rogers, and numerous others either performed or gave programs at the Hinton while it was in operation.

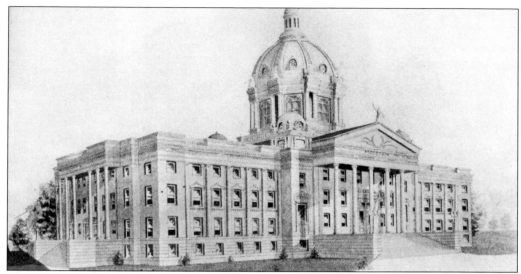

This artist's rendering appeared in Muskogee newspapers in 1905 and shows the capitol building of the state of Sequoyah that was proposed for Muskogee at that time. Though never built, the proposed capitol was to be located between Ninth and Eleventh Streets, on what is now Martin Luther King Street, in an area called Capitol Hill.

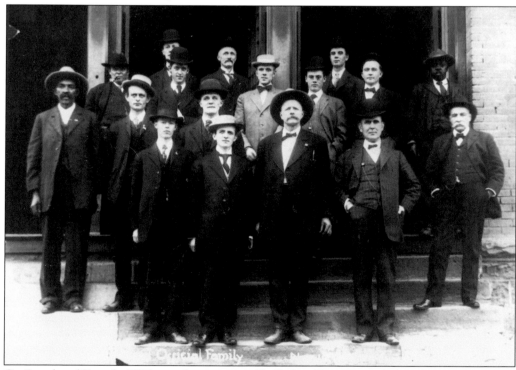

On Statehood Day, the US law enforcement staff of Indian Territory took this photo at the federal courthouse. In the center, with the wide hat, is US Deputy Marshal James "Bud" Ledbetter, who was one of the most important law enforcement officers in Indian Territory. The African American deputy on the far left is the legendary Bass Reeves, who is considered to be the most important African American lawman of his generation. (Courtesy of Oklahoma Historical Society.)

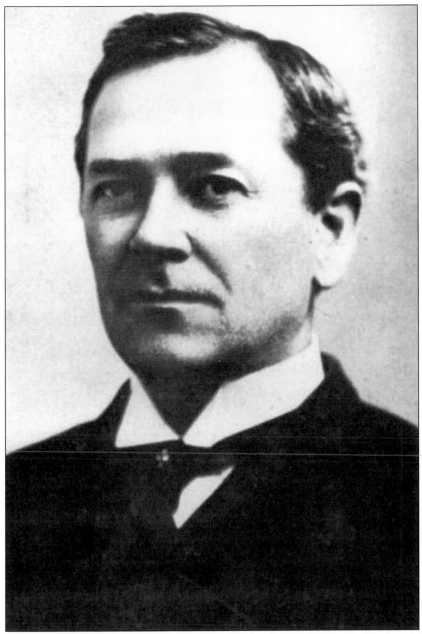

After the end of the 19th century, there was no one man as responsible for Muskogee's growth as Charles Haskell. Haskell first came to Muskogee in 1901 at the invitation of Judge John R. Thomas. After his arrival, he immediately made his mark with the building of at least four railroad ventures. He erected several buildings, including the Turner Hotel and the Indianola buildings. He promoted navigation on the Arkansas River, was chairman of the Muskogee State Fair, and was a moving force behind the Sequoyah Statehood Convention. Upon Oklahoma's statehood, Haskell was elected the first governor of Oklahoma, leaving Muskogee without its promoter at a time when the neighboring city of Tulsa was experiencing great growth. Haskell later returned to Muskogee, but his promotional efforts diminished. He died in 1933 and is buried in Greenhill Cemetery.

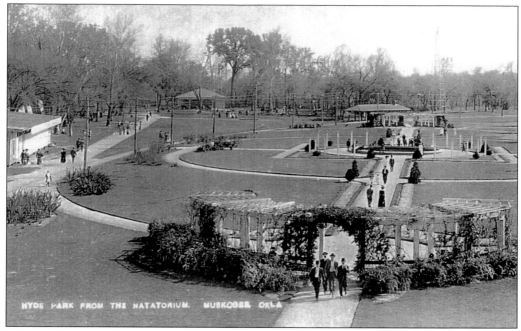

Known as a "pleasure resort," Muskogee's Hyde Park was built along the Arkansas River and developed by the owners of the Muskogee Electric Traction Company (a trolley car operator) in 1905. The park had beautifully manicured gardens, a natatorium (indoor pool), a small zoo, a skating rink, an arcade, a dance floor, picnic areas, and amusement rides. The park was a primary place for recreation in Muskogee until it closed in the late 1920s.

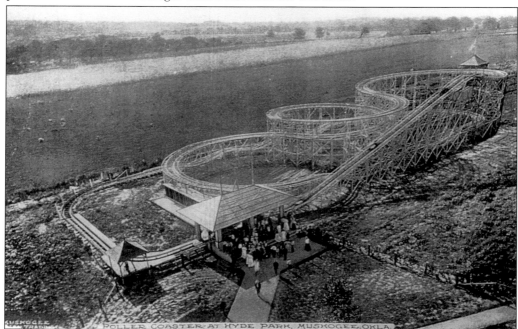

For many years, the main attraction at Hyde Park was the wooden roller coaster that sat along the banks of the Arkansas River. The roller coaster remained in Muskogee into the 1920s and was dismantled during the amusement park's demise at the start of the Great Depression.

In 1908, the Muskogee Commercial Club purchased this steamboat and named it the *City of Muskogee*. Boosters believed that the boat would promote Muskogee and further navigation on the Arkansas River. The boat made daily excursions out of its base in Hyde Park up until 1912, when it was purchased by Joshua Harman to transport freight between Muskogee and Little Rock, Arkansas.

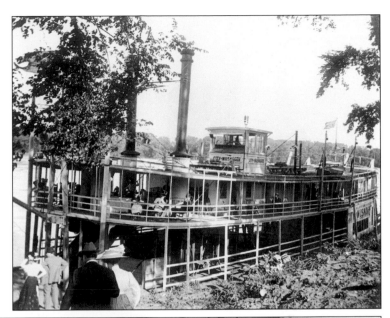

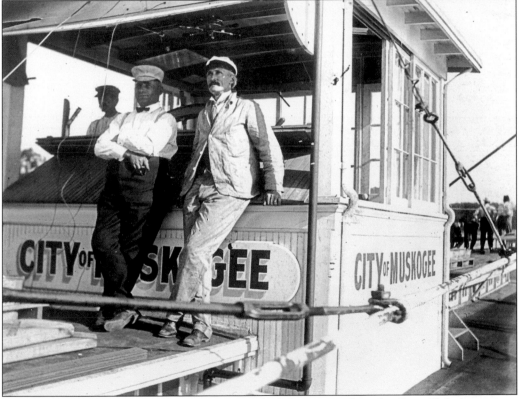

Prominent Muskogee resident Dr. Leo Bennett (right) is pictured on the *City of Muskogee* next to John Dudding. Bennett was not only a trained surgeon and dentist, he also served as a US Indian agent, founder of the *Muskogee Phoenix* newspaper, owner of the Adams Hotel, a director of the First National Bank, and as a US marshal before Oklahoma's statehood. Bennett died in 1917 of complications from tuberculosis.

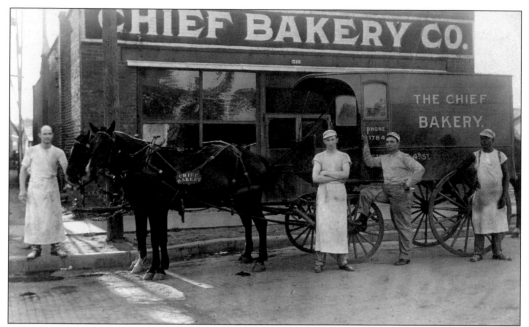

Muskogee's growth after the start of the 20th century attracted many entrepreneurs who came to the city looking to establish successful businesses. The Chief Bakery Company was located at 301 West Broadway and was owned by Claude Peters. The business shows up in city directories from 1907 to 1912 and was one of about eight bakeries in Muskogee during that time period.

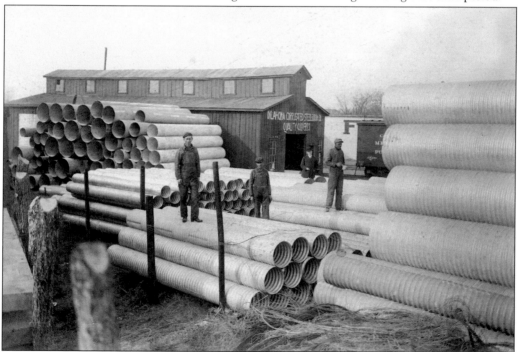

Oklahoma Corrugated Steel & Iron Company, which started in 1909, specialized in the manufacturing of culverts. The business was located at 411 S. Cherokee Street and operated until the late 1920s.

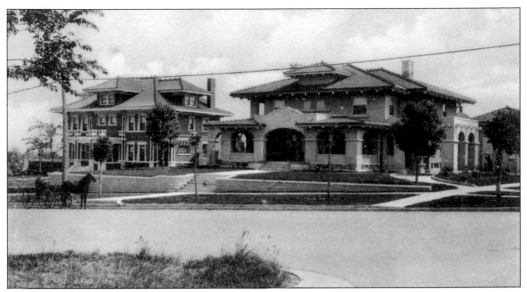

During the early part of the 20th century, as the city became a commercial and industrial hub, many grand homes were built in Muskogee. The Virgil Coss home (left) was built in 1906 and the George Murphy home (right) was completed in 1907. Coss was a banker and real estate dealer and Murphy was an attorney. Today, both homes are residences between Thirteenth and Fourteenth Streets on West Okmulgee Street.

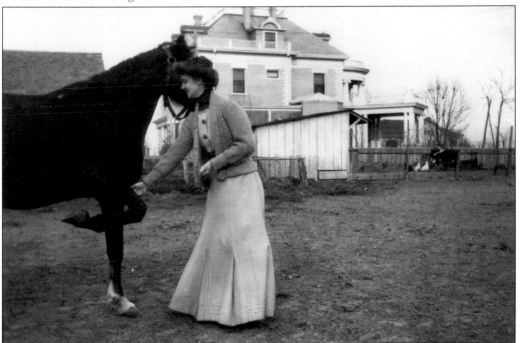

Author Carolyn Foreman, daughter of Judge John R. Thomas and wife of historian Grant Foreman, is pictured here with the judge's favorite horse on the back lawn of the Thomas-Foreman property in Muskogee. In the background, one can see the J.C. Welch mansion, which was constructed in 1904 and considered to be the finest home in Indian Territory upon its completion. Carolyn Foreman lived the rest of her life in the Thomas-Foreman home and died there in 1968.

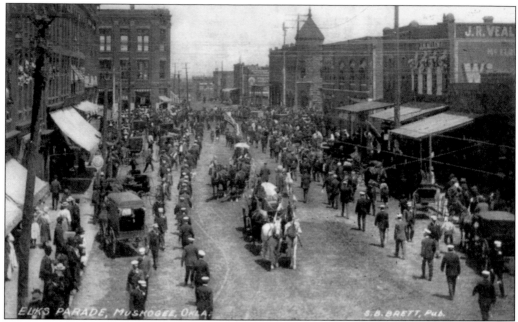

Muskogee's growth and increasing status brought many conventions and events to Muskogee. The Elks parade in Muskogee is pictured here in 1909. After Oklahoma achieved statehood, Muskogee hosted many large conventions.

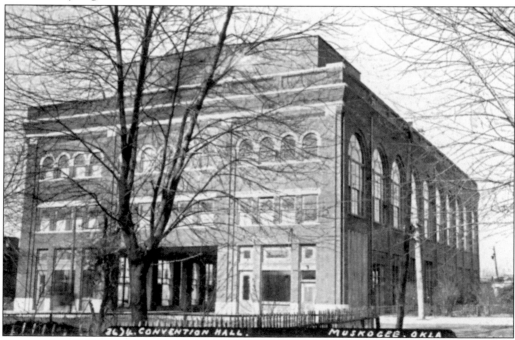

Convention Hall, located on South Main Street, opened in September 1907 and was principally financed by bankers Arthur C. Trumbo and his father-in-law, A.W. Patterson. The men were responsible for Muskogee being named the host city for the Trans-Mississippi Congress Convention of 1907 and they erected the building near their bank, Bank of Muskogee. In later years, Convention Hall was used as a market area, and in 1956 it was destroyed by fire.

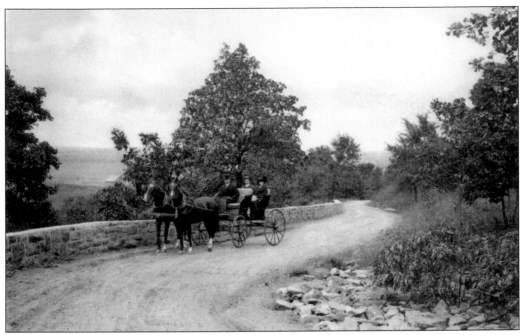

The area of Agency Hill (now Honor Heights Park) has been used for recreation and enjoyment for generations. In 1909, the City of Muskogee purchased the 132-acre area and designated it as City Park. It was common at the time for the area to be used for Sunday afternoon carriage rides, picnics, and hiking.

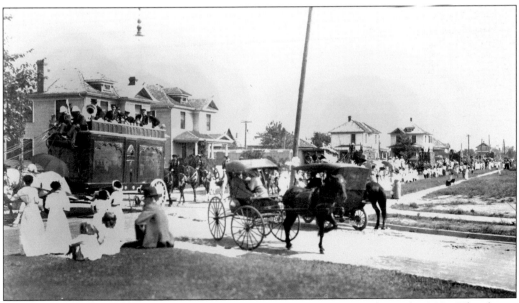

This lively image shows a circus heading down a Muskogee street in the early 1900s. The donor of this image identified the one automobile shown on the street as having a Muskogee license tag. This circus is likely either the Barnum and Bailey Circus or the Ringling Brothers Circus, both of which came to Muskogee during this period.

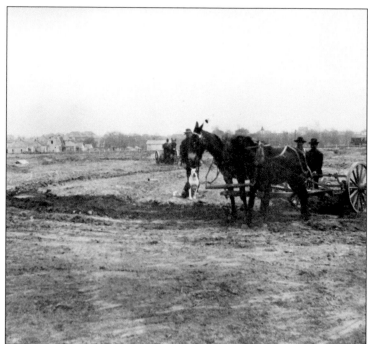

This picture was taken in 1909, as construction crews were beginning work on the pond area in Spaulding Park. After the fairgrounds moved from this site to their new location on South Cherokee Street, the park was further developed as a recreation area. The original gazebo, built in the middle of the pond, was completed in 1910 along with a wooden walkway.

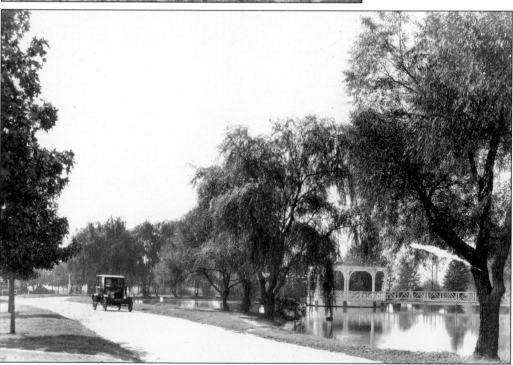

This image shows Spaulding Park after initial improvements were completed. The park soon became a popular location for recreational activities and has been developed further over the years. It has always been among the most popular parks in Muskogee and has been utilized by generations of Muskogee residents. The park was named in honor of pioneer Muskogee merchant Homer B. Spaulding.

Three

SKYSCRAPERS AND THE GREAT WAR
1910–1919

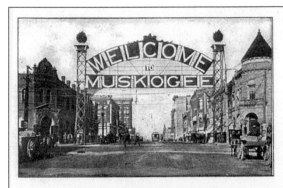

"*Muskogee, the Gem of the Southwest*"

(*Tune—Columbia, the Gem of the Ocean*)

Oh, Muskogee, the gem of the Southwest,
 Muskogee, that's famed far and near
For its growth and its live, hustling people,
 That are building new homes here each year;
In 1900 she'd but ten thousand people,
 But she boasts thirty thousand today,
For we stayed when we came for a visit,
 And we boost for Muskogee today.

CHORUS

We boost for Muskogee today,
 We boost for Muskogee today,
For we stayed when we came for a visit,
 And we boost for Muskogee today.

We have torn down the shacks and built higher,
 Built structures that all view with pride ;
Built churches and high schools and ward schools,
 And have colleges on every side.
We have miles upon miles of street railway,
 And paved streets that are ne'er blocked with snow;
If you come and but visit our city
 You will boost for Muskogee, we know.

CHORUS

You will boost for Muskogee, we know,
 You will boost for Muskogee, we know,
If you come and but visit our city,
 You will boost for Muskogee, we know.

Muskogee's the center of railroads,
 We've a water route straight to the sea;
So our strength lies in part in our commerce,
 Tho' we've oil, gas and coal, wondrous three.
We have plenty of fine city water,
 With our climate there's none can compare,
Then hurrah for the gem of the Southwest,
 Muskogee, Muskogee, so fair.

CHORUS

Muskogee, Muskogee, so fair,
 Muskogee, Muskogee, so fair,
Then hurrah for the gem of the Southwest,
 Muskogee, Muskogee, so fair.

—M. L. M.

(*All Rights Reserved*)

By 1910, Muskogee was in the midst of a strong building boom, with ongoing construction projects spread throughout the city. Muskogee's skyscrapers—the Surety, Flynn-Ames, Equity, Phoenix, and Severs Hotel—were all at some level of construction. At the time, the city boasted of having 10 buildings that were more than five stories tall. The city's streets were bustling with activity and new projects were regularly proposed in the community. One such proposed project was the building of a replica of the Taj Mahal in Muskogee. Though this and many other projects never came to fruition, they are indicative of the entrepreneurial spirit and excitement that was present during this period. A promotional song, shown here on a postcard, was composed during this time to highlight Muskogee's ongoing growth and opportunities.

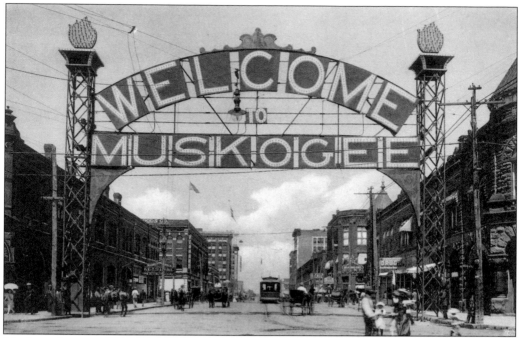

Muskogee's iconic "Welcome Arch" (pictured here in daylight and at night) was erected by the Muskogee Gas and Electric Company in October 1910 at a cost of $2,900. The sign was located at the west side of the intersection of Broadway and Main Street. At the time it was built, it was one of the largest arch structures in the United States and was taller than nearby buildings. The sign was an entryway into the city for passengers arriving on the MK&T (Katy) railroad and was lit at night with tungsten electric bulbs. The arch was dismantled in 1915 due to the cost of the lighting, the birds that flocked to the sign, and complaints from nearby business owners.

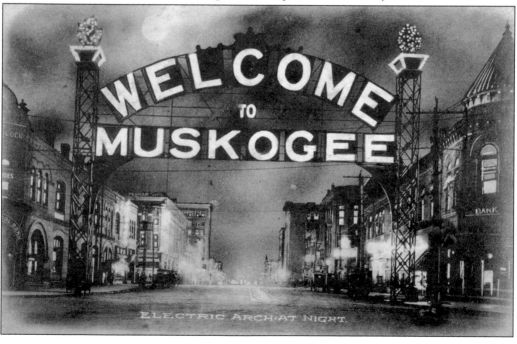

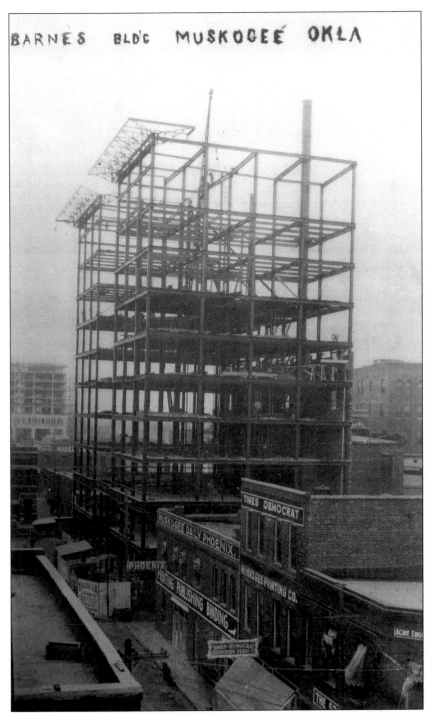

BARNES BLD'G MUSKOGEE OKLA

The Barnes Building, the tallest commercial building built in Muskogee, is pictured here under construction. It was completed in 1911 at Third and Wall Streets at a cost of $300,000. The builder, George W. Barnes, came to Muskogee after selling off oil holdings from the Glenn Pool oil field in Eastern Oklahoma for over $1 million. However, while on a trip to Monte Carlo, Barnes died before the building was completed. The building was razed in the 1970s.

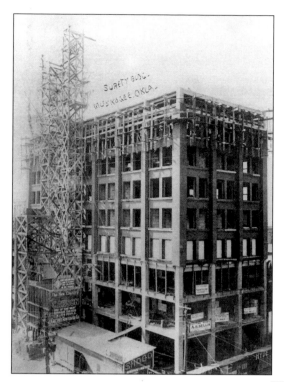

The Surety Building, on the southwest corner of Third Street and Broadway, is shown here during construction in 1910. The eight-story skyscraper was built for the Southern Surety Company, which had offices in the building. The building was the longtime home of McEntee's Jewelry, which was located on the first floor, facing Broadway. In 2005, the building was purchased and remodeled into senior apartment homes.

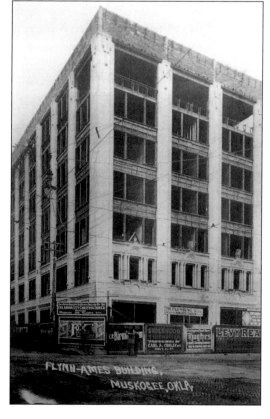

The Flynn-Ames Building was under construction at the same time as the Surety building. The Flynn-Ames was an ornate seven-story structure on the northeast corner of Third and Broadway, across from the Barnes building on Wall Street. Exchange National Bank was located in the building before its merger with Commercial Bank, which then became a longtime occupant of the building.

Frederick B. Severs (affectionately known as Captain Severs) first came to Muskogee in 1884 and established the Severs Cash Store. Severs served with the Creek Mounted Volunteers during the Civil War and afterward was given citizenship in the tribe. Severs later acquired a large area of land, which he rented out to tenant farmers and on which he maintained a large cattle herd with as many as 25,000 head of cattle. He was an original organizer of the First National Bank of Muskogee and built the Severs Block building to serve as its offices.

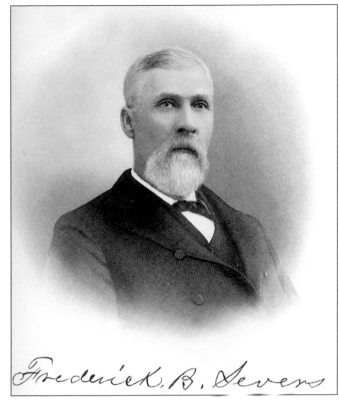

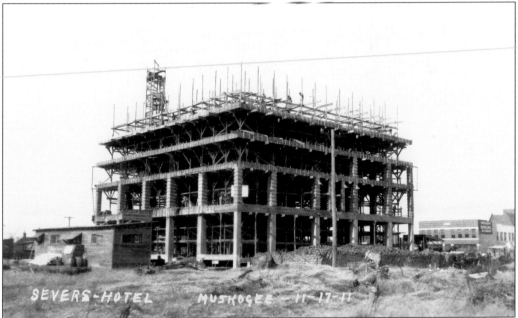

As Severs aged, he wanted to leave a lasting monument and decided to build a grand hotel for Muskogee. Construction of the Severs Hotel began in 1911, with Severs supervising on site on a daily basis. Sadly, Severs died on April 23, 1912, within a few months of the opening of the hotel. This image shows construction on the hotel, which was built on Severs's former homesite.

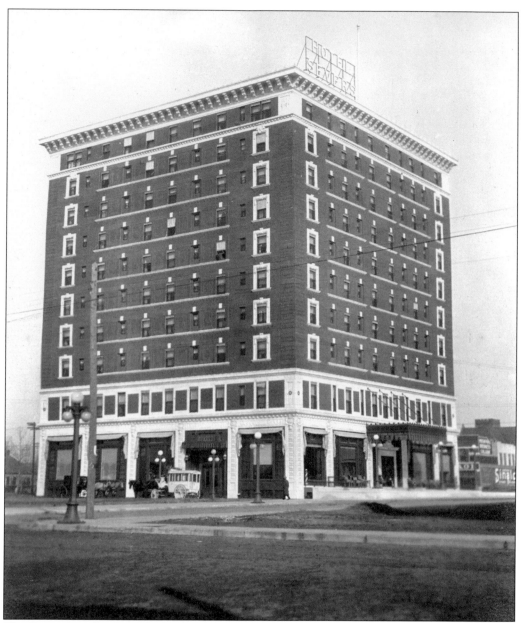

The Severs Hotel opened for business on September 1, 1912. At the time, the *Muskogee Phoenix* called it "the handsomest hotel in the southwest." The 10-story building was filled with first-class items, including an eye-catching winding marble staircase in the lobby. There were 216 rooms in the hotel, including 146 rooms with private baths. A cold storage plant furnished circulating ice water to every floor. When it opened, the rate for a room was $1 per day, or $1.50 if a bath was included. During the opening, the Muskogee Transfer Company provided special cabs trimmed in gold and driven by white horses to take passengers from the railroad depots to the hotel. Many celebrities and important people stayed in the Severs over the years, including Babe Ruth, Helen Keller, Will Rogers, Eleanor Roosevelt, Burt Lancaster, and others. The hotel closed in 1975 and the building fell into disrepair. After years of effort, it was restored in 1988 and converted to a bank and office building under the leadership of Muskogee banker Harry Leonard.

This c. 1913 image is of the corner of Third and Okmulgee Streets, looking north. The newly constructed Barnes Building is shown here (center), along with the Flynn-Ames Building (right). The Indianola Building is on the left, with the Union State Bank sign on the front corner. Today, none of these three buildings remain as shown here.

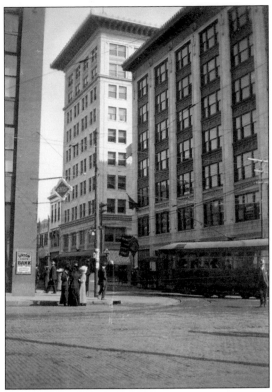

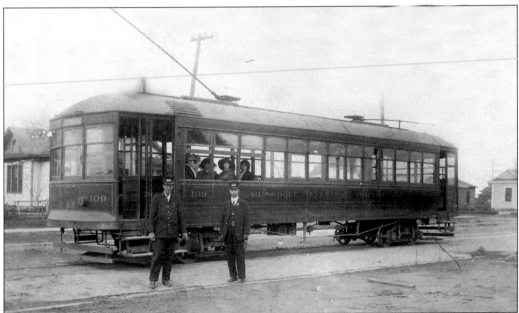

Trolleys were a popular source of transportation in Muskogee. The Electric Traction Company's major traffic producer, the 10-mile interurban line to Fort Gibson, was constructed in 1911. Other destinations were an early baseball park—Benson Park—on South Twenty-First Street and Hyde Park. The company reached its peak operation in 1916, with 31 miles of track, including a line to the Muskogee Fairgrounds and one to Bacone College.

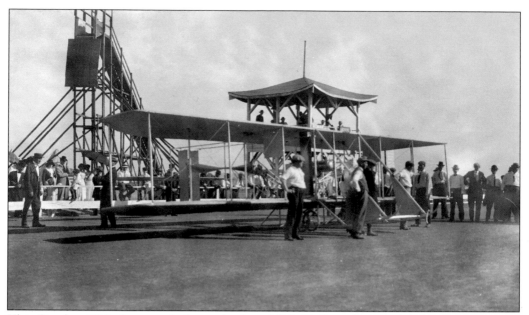

This October 1911 photograph shows the famed "Viz Fin" airplane at the new fairgrounds in Muskogee. The airplane was in town as part of a contest to become the first to fly across the United States. Cal P. Rodgers piloted the plane, traveling 4,321 miles in 84 days; Muskogee was one of his stops. This was the first time that most people in Muskogee had ever seen an airplane.

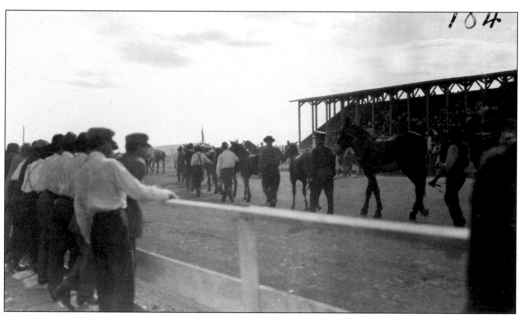

Muskogee's historic Thunderbird Speedway began as a horseracing track. The track was built at the fairgrounds after it was moved from Spaulding Park. This picture was taken around 1911, after the new track was in operation.

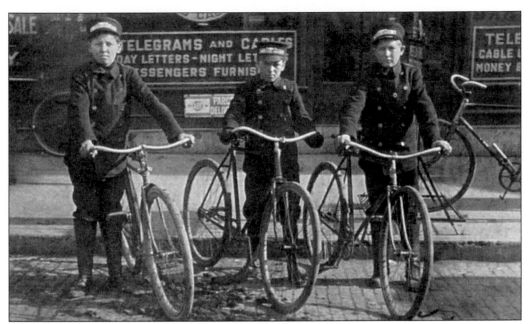

The Western Union messenger boys were always ready for a delivery. They bicycled around town delivering telegrams, messages, and other items. From left to right, Clifton Butler, Willie Barnett, and Roscoe Tryon are pictured outside the Western Union office at 104 North Second Street.

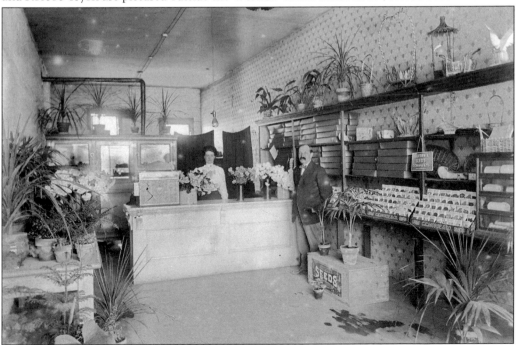

This 1910 photograph shows the interior and staff of the Muskogee Carnation Company after Robert Bebb purchased the business. The name was later changed to Bebb Floral Company. Bebb was an avid botanist and made many important discoveries during field trips near Braggs Mountain, east of Muskogee. The business remains open today, although under different ownership, and is considered the second-oldest flower shop operating in Oklahoma.

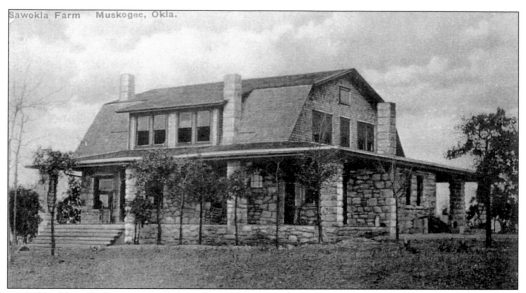

In 1910, Alice Robertson built her famed home, "Sawokla," on Agency Hill (Honor Heights). The home looked out over the Arkansas River toward the old Tullahasse Mission, and included 100 linear feet of porches wrapping around three sides, which were used quite often for social activities. The home burned down in 1925; however, the cornerstone is now on display at the Three Rivers Museum.

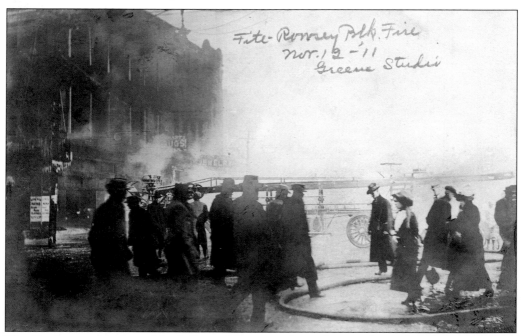

The Fite-Rowsey block, on North Second Street, is shown here in the midst of a major fire on November 12, 1911. The building previously served as the headquarters for the Dawes Commission and was built by physician Frances B. Fite and his brother-in-law, banker William E. Rowsey. The building was heavily damaged in the blaze.

Workmen take a break on some scaffolding during the construction of Muskogee's new federal courthouse in 1914. Located at 101 North Fifth Street, the building included a US post office when it first opened.

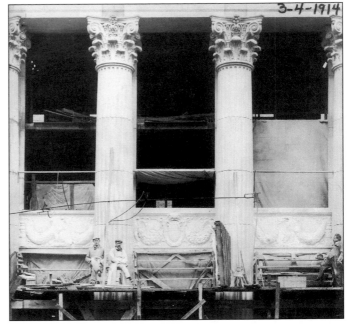

This aerial image shows construction in progress at the Muskogee Federal Courthouse in 1914. The building was renamed the Ed Edmonson US Courthouse in 2003 and has subsequently been restored. In the distance, at the top, one can see the original sanctuary of the First Baptist Church of Muskogee at Seventh and Okmulgee Streets.

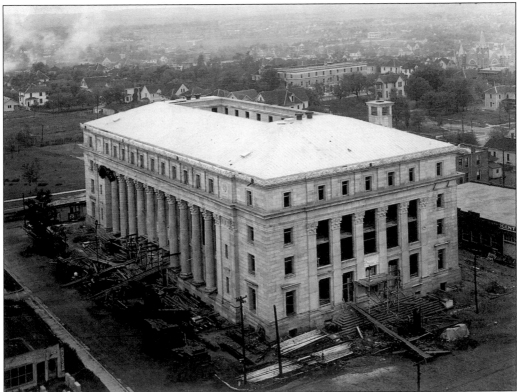

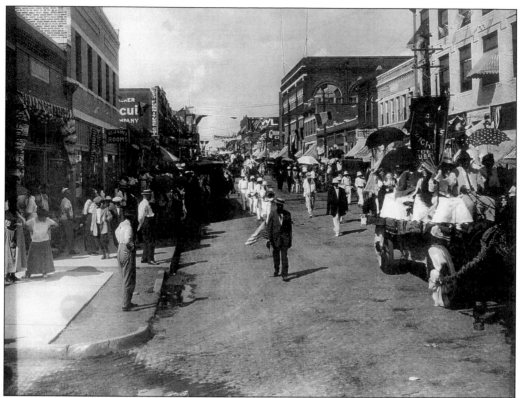

This parade scene shows the National Baptist Sunday School Congress, which met in Muskogee in June 1913. This view is looking north from Elgin Street and shows the heart of the African American business district. Part of the current Gospel Rescue Mission can be seen in the right foreground, and farther up the street is the west end of the former Convention Hall.

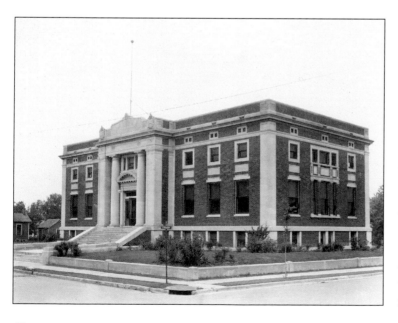

Muskogee's Carnegie Library opened in the midst of a driving rain on May 1, 1914, at 401 East Broadway. The city accepted a grant from the Carnegie Foundation to help finance construction. The library moved here from its previous location on the fourth floor of the Equity Building. A new library was constructed in 1972, and this building has since become home to a nonprofit foundation.

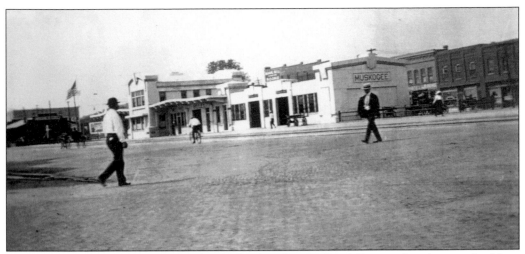

This scene on Elgin Street shows the Midland Valley Railroad Depot after the new building was erected in 1917, replacing the former frame structure. The depot was built by Manhattan Construction Company of Muskogee at a cost of $25,000. After a long and storied past, this building is the present-day home of the Three Rivers Museum.

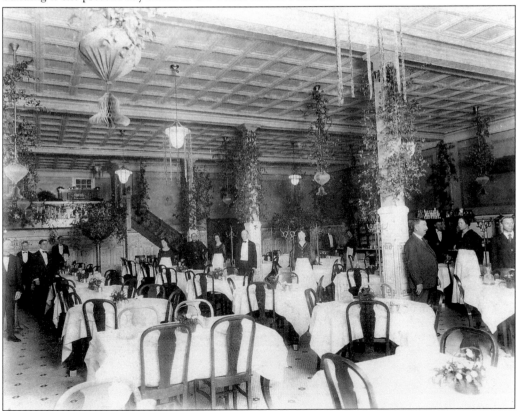

Opened in 1918 and pictured here, the Puritan Café was owned by John Coe, who was formerly the manager of the dining room at the Turner Hotel. The restaurant had uniformed waiters, soft music, and gourmet food. The Puritan Café was located at 425 West Broadway in the building later occupied by Sears before its move to Arrowhead Mall.

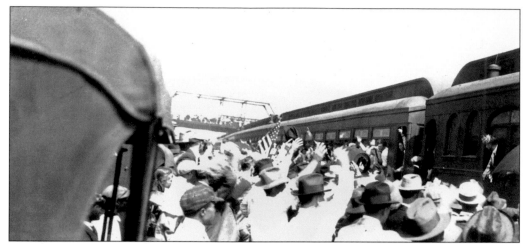

World War I troop trains were always greeted with enthusiasm as they went through Muskogee. In this scene, the crowds not only swarm around the depot, but also in the background on the Court Street Viaduct—the bridge over the railroad tracks built for the trolley cars. Alice Robertson was noted for providing coffee and refreshments for every such train that went through Muskogee.

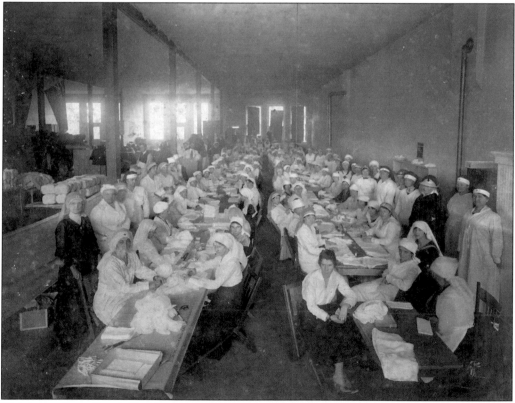

This image shows female Red Cross volunteers preparing packages of bandages and surgical dressings for American troops fighting in World War I. Alice Robertson and Carolyn Foreman were the principal organizers of Muskogee's Red Cross efforts during World War I. The entire first floor of the Railway Exchange Building (now Haskell Building) at Second and Court Streets was used by the Women's Work Department, with workers usually there from 8 a.m. until midnight.

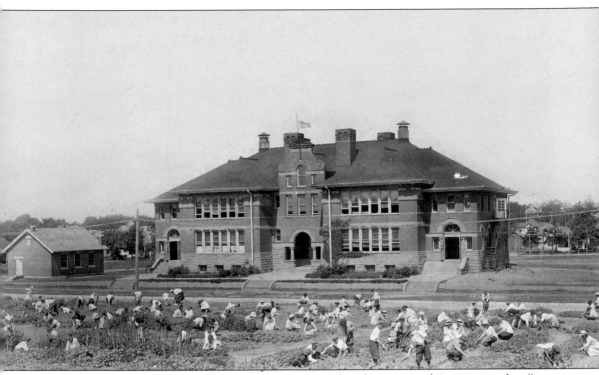

During World War I, several Muskogee schools planted and maintained "victory gardens" to contribute to the cause. Gardens such as these were promoted heavily by the US government because of a worldwide drop in food production during the war. Victory gardens produced up to 40 percent of all vegetables consumed in the United States during the Great War. This photograph is of Muskogee's Jefferson School, which was located on Eighth Street between Columbus and Boston. In this image, students work in the garden in front of the school.

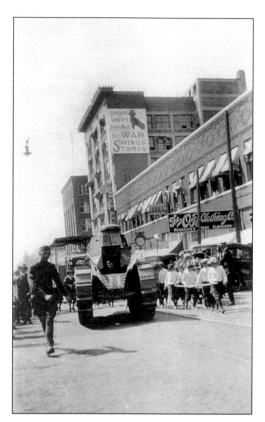

World War I tanks are shown on parade down Broadway. Muskogee held several parades during and after World War I; this photograph is undated, but may have been taken at a parade held in Muskogee on April 3, 1918, for the dedication of the War Savings Bank. Former president William Howard Taft was the guest of honor at the parade, and an estimated 15,000 people crowded downtown Muskogee during the event.

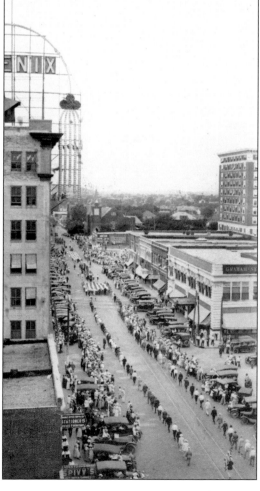

This image shows soldiers who have returned from World War I walking down Broadway in a parade. The photograph was taken from the Surety Building and shows a close view of the Phoenix Building (later renamed the Manhattan Building), complete with a sign that was lit at night. The First Presbyterian Church is visible in the center background.

These two ladies are pictured on a cold, snowy day near the new YMCA. In 1914, the former Maddin Hardware Store building was purchased and converted into the YMCA, which used the facility for many years. The building remains in Muskogee today.

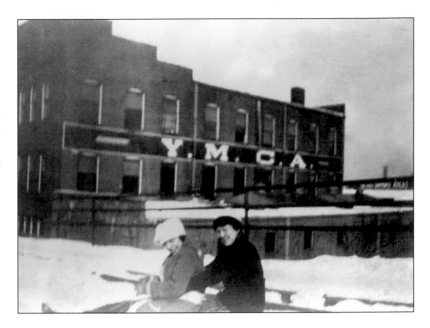

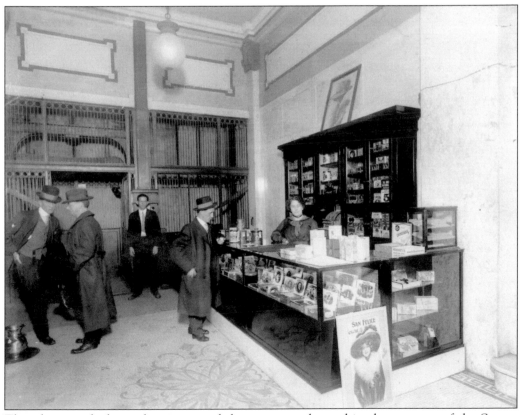

This photograph shows the cigar stand that was once located in the entrance of the Surety Building at Third and Broadway. Many of the Muskogee skyscrapers had cigar or newsstands in their lobby areas.

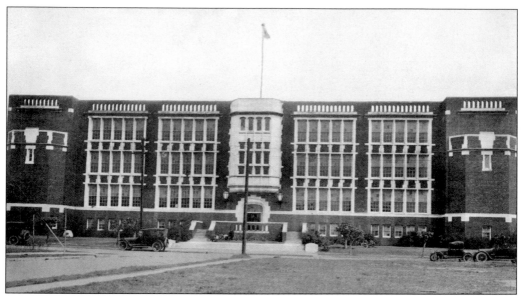

After many years of moving between several buildings, Muskogee's high school—named Central High School—was built in 1910 at Dayton and E Streets. As was the case with most schools of the time, only white students were admitted. This photograph is believed to have been taken within a few years of the opening of the school.

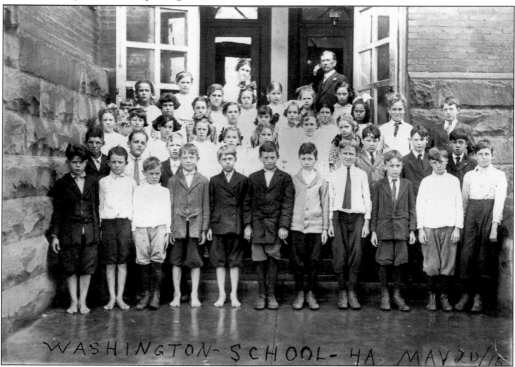

The fourth-grade class of teacher Norine Hughes is pictured here at Washington School in 1915. Hughes is standing in the back, along with school principal C.B. Smith. Washington, constructed in 1904, was the first public school building in Muskogee. Smith was the principal from 1909 to 1923 and regularly hosted a silent movie night on Fridays to raise money for school equipment.

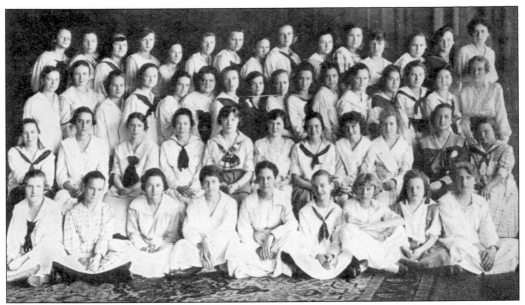

Muskogee's Mistletoe Girl Scout troop, shown here, is nationally recognized as being the first troop in the county that sold Girl Scout cookies. The troop, led by Marion Brown, baked and sold the cookies at Central High School in 1917 to earn funds to send Christmas bags to soldiers overseas. A statue commemorating this achievement is located in front of Three Rivers Museum.

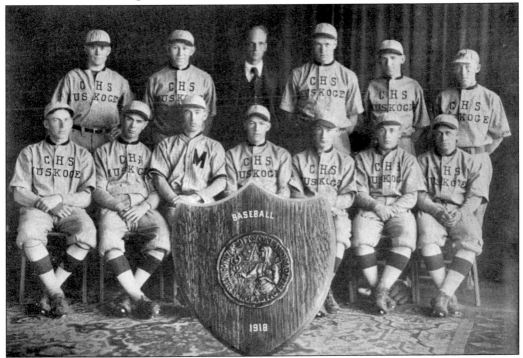

The 1918 state champion Central High School baseball team is pictured here. The team won four games at the state tournament in Norman, including a hard fought victory over Guthrie in which Central won 9-8. The team later beat Lindsay 23-3 in the championship game. Shortstop Berry Cotton (first row, center) was team captain and also the senior class president.

The growth of automobile use during the 1910s was substantial. By 1919, nearly nine million cars were registered to drivers in the United States. The posted speed limit in downtown areas at this time was eight mph, with 16 mph allowed in other parts of town. This Model T is shown in front of the old Agency Building (now Five Civilized Tribes Museum).

The old Agency Building was a popular place for taking pictures with a Brownie camera or other similar equipment (commonly called "Kodaking"). This adventurous group evidently wanted to do something a little different and climbed on top of the Agency Building to take their pictures on the roof.

Four

A GREAT PLACE TO CALL HOME
1920–1939

By the 1920s, growth in Muskogee had leveled off, and the city had a population of just over 30,000. Nearby Tulsa had overtaken Muskogee as the second-largest city in the state and became known as the "Oil Capital of the World." Tulsa's growth was spurred by being geographically closer to the oil field discoveries in Eastern Oklahoma and having better direct rail access to these larger fields. Muskogee settled down to become a commercial and industrial hub for Eastern Oklahoma and, at the time, was still the third largest city in the state. This promotional image from the 1920s shows Muskogee as a central part of activity in the region.

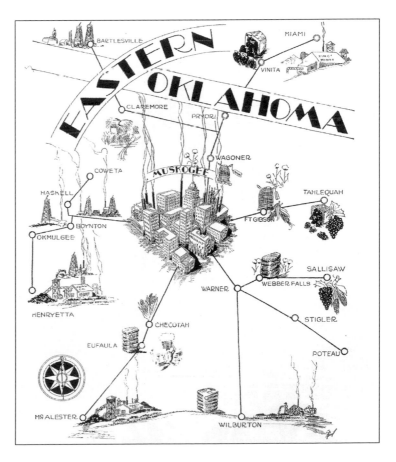

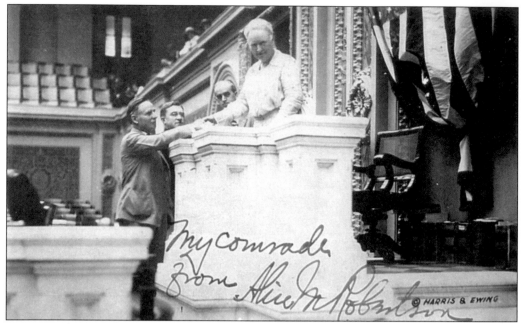

In 1920, at the age of 67, Muskogee's Alice Robertson was elected to the US House of Representatives. She was the second woman elected to Congress and the first female representative from Oklahoma. This picture shows Robertson presiding over a session of Congress in 1921, which was a first for a woman in US history. She was a popular figure in Washington during her term, but was defeated in her bid for a second term in 1922.

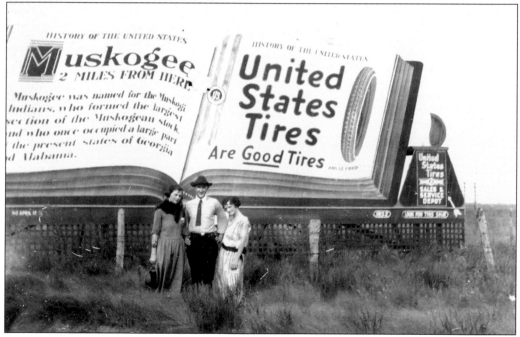

A man and two women stand in front of a creative United States Tire sign that shows them to be "two miles from Muskogee." In 1921, the United States Tire dealership in Muskogee was located at 435 West Broadway.

This early photograph of Muskogee's Veterans Hospital is from the 1920s. The hospital was originally built beside City Hospital on Agency Hill, but in 1925, Muskogee sold the hospital to the federal government because its location was too far from the center of town and created a new hospital in the former Spaulding Institute Building near Spaulding Park. The former City Hospital was joined to the Veterans Hospital in 1937.

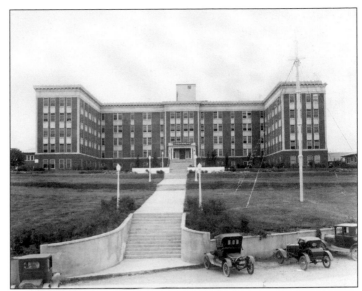

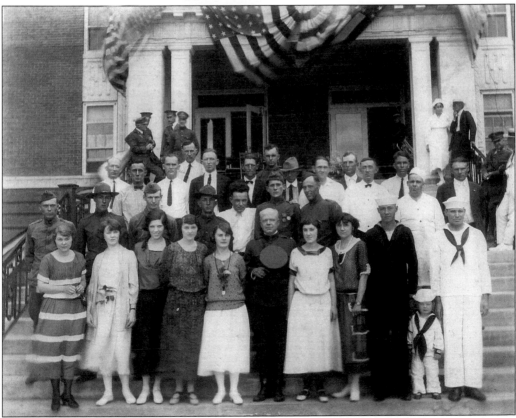

The Soldiers Hospital (now Veterans Hospital) opened on June 14, 1923. Staff members and military personnel are shown here on the front steps. The first patient of the hospital was Henry Haig, who received three citations for his bravery during World War I and had been in a coma for eight months before regaining consciousness. Alice Robertson was a social worker at the hospital in 1924, after her term in Congress.

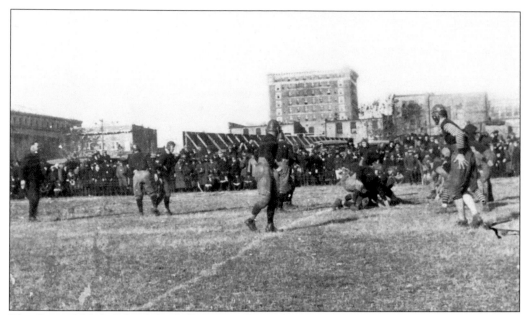

The Central High School football team is shown here on November 11, 1920, in the midst of a game against Oklahoma City's Central High School at Athletic Park in Muskogee. Several thousand people were said to have crowded the stands to see Muskogee win 14-2. Muskogee was undefeated during this season and claimed its fourth state championship. The team was dubbed the "Roughers" within a few years after this season.

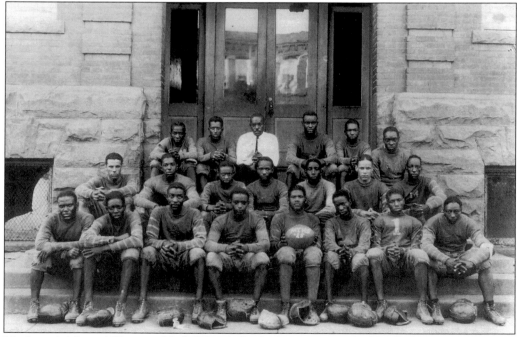

Muskogee's Manual Training High School also had a great record of football success. The 1925 Manual Training team is pictured here on the steps at the school. The 1925 team suffered a disappointing defeat against Tulsa's Booker T. Washington High School, but in 1926, they beat Tulsa Washington 9-7 and claimed a state championship.

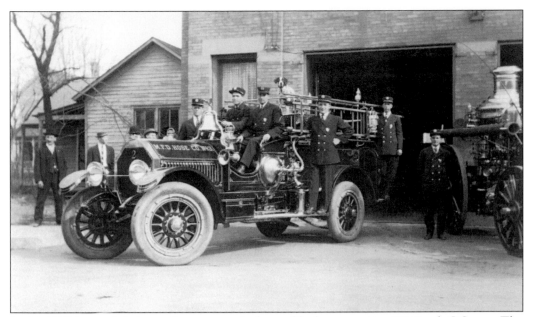

In this 1922 image, Muskogee firemen pose in front of firehouse no. 2 at 212 North C Street. The historic Pat Byrne fire engine is shown off to the right. This engine was bought by the city of Muskogee after the 1899 fire and was named for Patrick Byrne, the first mayor of Muskogee. The engine is now on exhibit at the Oklahoma Firefighters Museum in Oklahoma City.

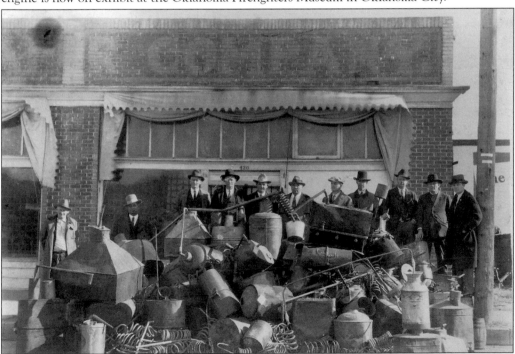

Sheriff James F. "Bud" Ledbetter (fourth from left), along with deputies and a federal agent, is shown in front of a large collection of seized still equipment in this 1924 image. Ledbetter, who was 72 at the time, served as a law enforcement officer for nearly 50 years. The building pictured is assumed to be the Marshall Lumber Company, which was across from the jail on Third Street.

The Grand Theater, located at 115 South Second Street, served the African American community in Muskogee for many years. The theater was built in 1904 as a vaudeville house and was later converted into a movie theater. The movie shown to be playing in this photograph is *Plunder,* starring silent movie actress Pearl White, which indicates a date around 1923.

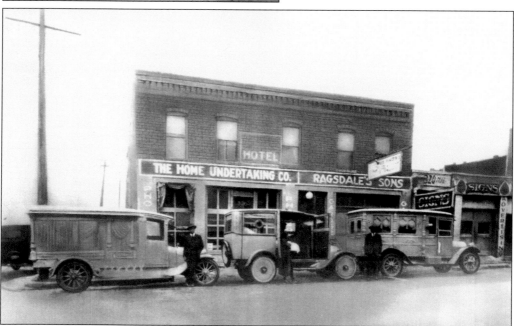

This photograph shows the Home Undertaking Company, located at 325 North Second Street, in the early 1920s. The business was started in 1896, when African American William Ragsdale bought the former Creek Livery Barn. In the early days, it was both a funeral and livery stable business. The Home Undertaking Company is considered to be the longest running business in Muskogee and has served the community for 115 years.

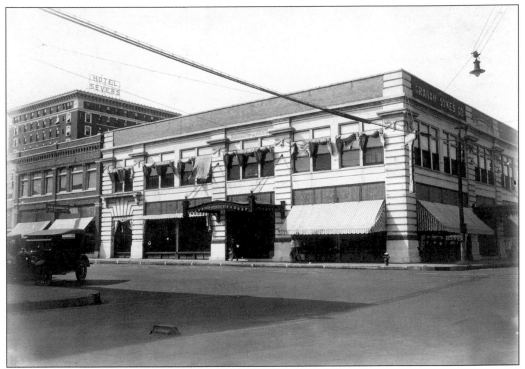

This image shows the exterior of the Graham-Sykes Department Store, which was located on the northwest corner of Third Street and Broadway. This was a popular department store in the early part of the 20th century. Recently, the building has been restored and converted into the Muskogee County Services Building.

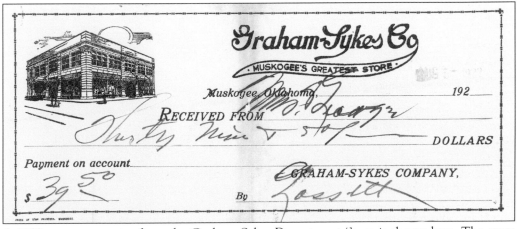

A 1922 payment receipt from the Graham-Sykes Department Store is shown here. The store closed by the mid-1920s; Montgomery Ward occupied the space soon after.

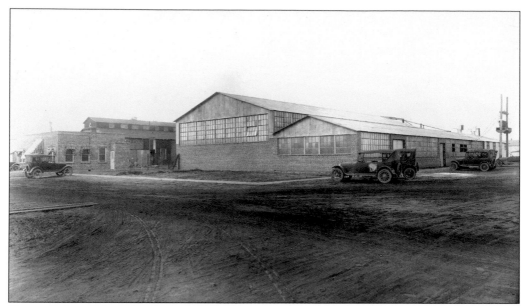

Originally founded in Missouri under a different name, Muskogee boosters convinced the Muskogee Iron Works to move operations to Muskogee in 1909. The business was diverse and included structural steel construction, foundry work, galvanizing, and equipment manufacturing. In the 1920s, the company grew to become one of the largest businesses of its kind in the southwestern United States. This photograph from 1923 shows the exterior of the business.

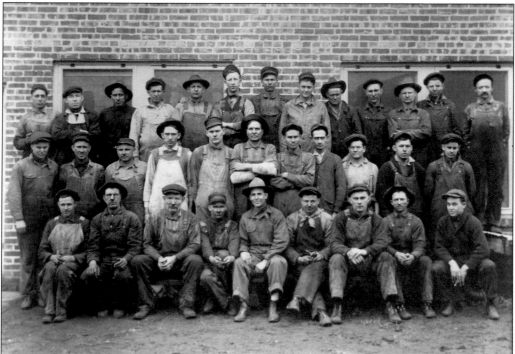

This 1921 photograph shows Muskogee Iron Works shop workers posing in front of the Engineering Building. The business was located at the intersection of Frankfort and Spaulding Streets and remained an important part of the city until it closed in the 1980s.

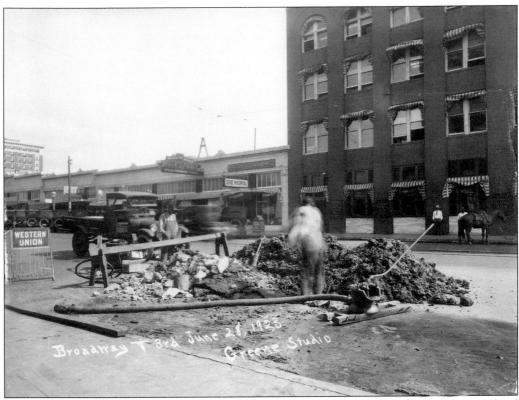

This view from June 1923 shows construction workers in the middle of the street at Third Street and Broadway in front of the Indianola Building, likely fixing a water line problem. From this photograph, it is clear that even as late as 1923 it was not uncommon to see a horse in downtown Muskogee.

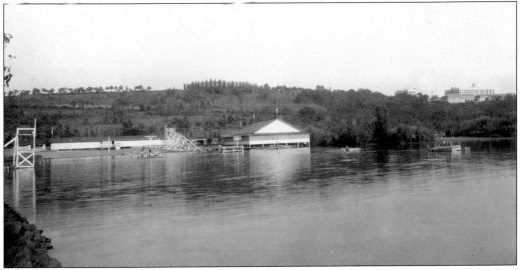

The pond area in Honor Heights Park was once known as Stem Beach. This photograph shows the site, which included a skating rink, swimming area, boating area, and an arcade. Jazz musicians also played regular concerts at Stem Beach.

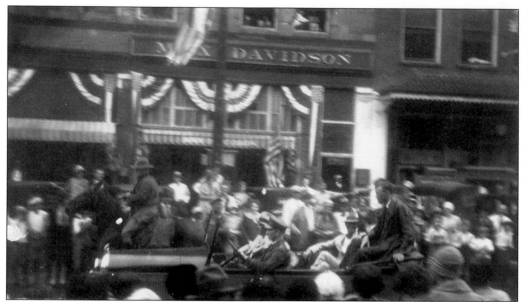

On October 1, 1927, Charles Lindbergh flew into Muskogee while on a promotional tour following his historic *Spirit of St. Louis* flight. When entering the city, Lindbergh made a special flight over the School for the Blind so students there could hear his airplane. At Hatbox Field, he gave a three-minute speech and praised the facility. This photograph shows Lindbergh being taken by automobile through the crowds in Muskogee.

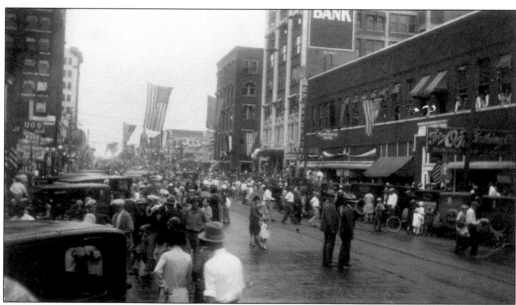

Muskogee leaders planned a parade for Lindbergh in order to allow more people to see him. Lindbergh authorized this special parade the day before his arrival. People from all over the region flocked to Muskogee and crowds were estimated to be over 60,000. This photograph shows the crowds along Broadway soon after the automobile carrying Lindbergh had passed.

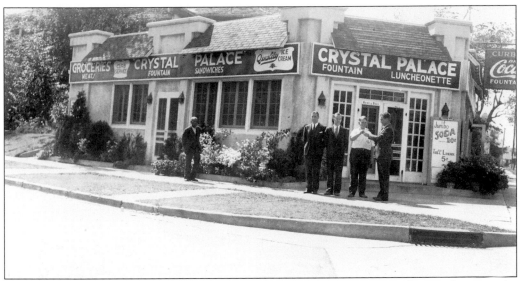

The Crystal Palace, located near Irving School on Gibson Street, was a favorite hangout for students in Muskogee during the 1930s and 1940s. The business, which was well known for its excellent food and soda fountain, was owned by Morris Johnson, who is shown here at far right next to his son Sam Johnson (white shirt).

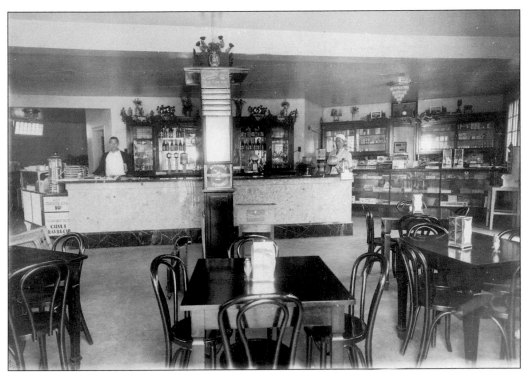

This image shows the interior of the Crystal Palace. In the center is a sign that designates the business as an official Mickey Mouse Store.

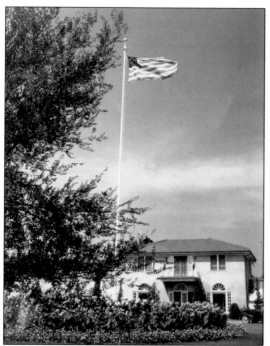

Bresser's Nursery began in 1910, when Henry and Cecelia Bresser moved their family from Ohio to Muskogee. Bresser was a German immigrant, and after arriving, purchased a large American flag that he kept for years. This 1931 photograph shows the newly built Bresser's Nursery location, with the beloved flag flying on a large pole.

The image below shows the interior of Bresser's retail store on York Street upon its grand opening in 1931. The Bresser store and adjoining residence were built across York Street from Greenhill Cemetery. The Bresser family began growing azaleas in Muskogee in the 1920s and introduced the flowers into Honor Heights Park.

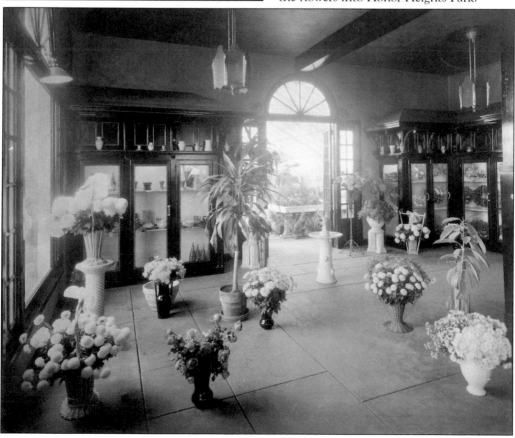

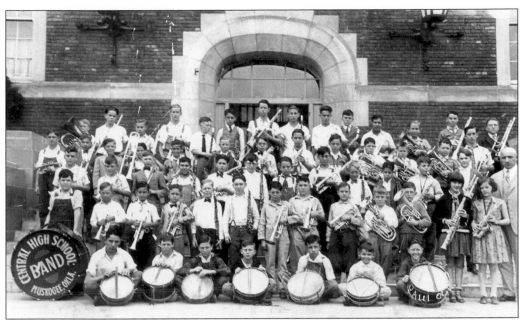

Muskogee's Central High School Band is shown here with director Tony Goetz (at far right). Goetz was a graduate of the Beethoven Conservatory of Music in Hungary and came to Muskogee in 1922. Members of the marching band were males, with females playing in the orchestra. Many of the students in the band were younger than high school age, as Goetz believed that if a student excelled in music, he or she could be part of the band or orchestra.

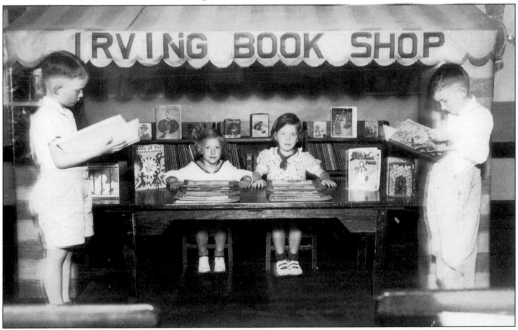

This 1935 image from Irving School shows first-grade students in a school bookstore. The original Irving School opened in 1909 at Gibson and J Streets, on the east side of Muskogee, and was named for American author Washington Irving. The original building has been replaced with a modern building at the same site.

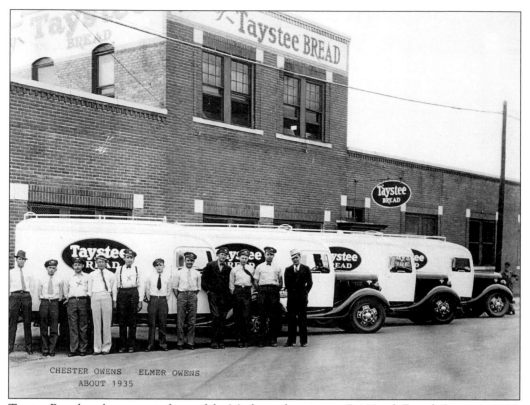

CHESTER OWENS ELMER OWENS
ABOUT 1935

Taystee Bread workers pose in front of the Muskogee location, at 519 North Fourth Street, in 1935. The men identified on the picture, Chester and Elmer Owens, were both route salesmen for the Nafziger Baking Company, which owned the Taystee Bread brand name. The business started in 1930 in Kansas City, Missouri, and is currently known as Interstate Bakeries Corporation.

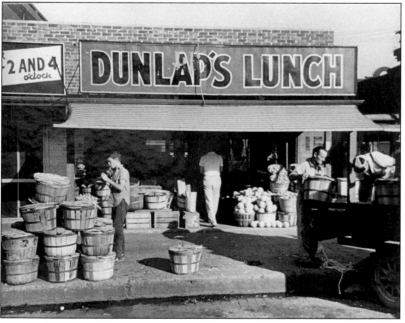

Dunlap's Lunch Stand, shown here in the 1930s, was located on South Main Street for a short time. At this time, South Main contained many grocery and fruit stand operations.

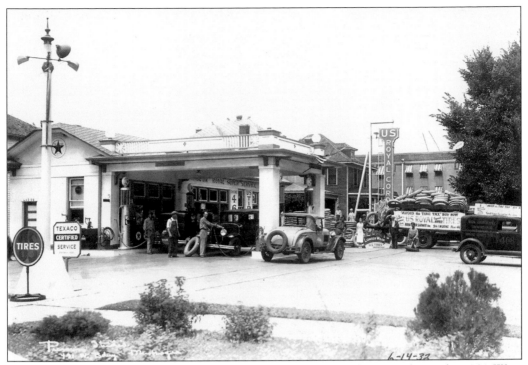

This image from 1932 shows the Royal Super Service Station business, located at 901 West Okmulgee Street. The owners and staff of the business are visible in the background, near the stacks of tires. Note the signs that say "Avoid the Tire Tax," which refers to a tax on tires that was about to be enacted.

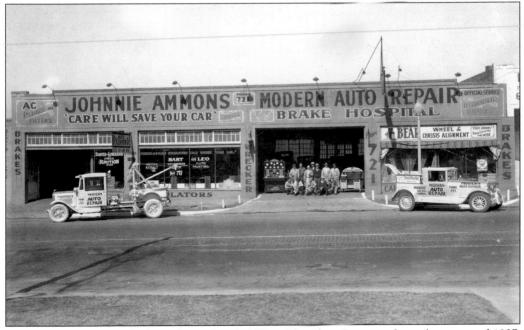

Modern Auto Repair, which was located at 606 West Okmulgee Street, is shown here around 1937. The business was owned by John Ammons and was previously known as the Brake Hospital.

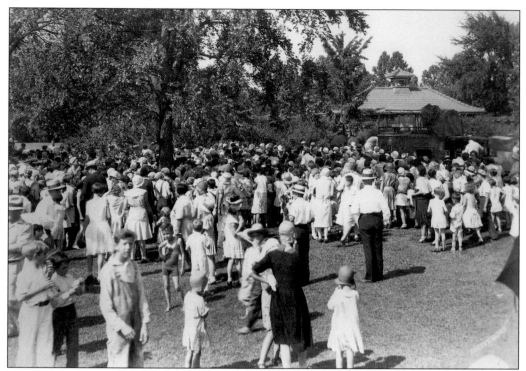

This large crowd in Spaulding Park in the 1930s is full of people anxiously awaiting their turns at the Steffen's Ice Cream truck. Steffen's, based out of Wichita, Kansas, was a popular brand of ice cream at the time.

In the 1930s, further landscaping efforts began at Honor Heights Park. This image from 1933 shows road construction and landscaping activity in process on the west side of the hill. The park was under the direction of George Palmer and, in 1935, won a national prize of $1,000 from *Better Homes and Gardens* magazine.

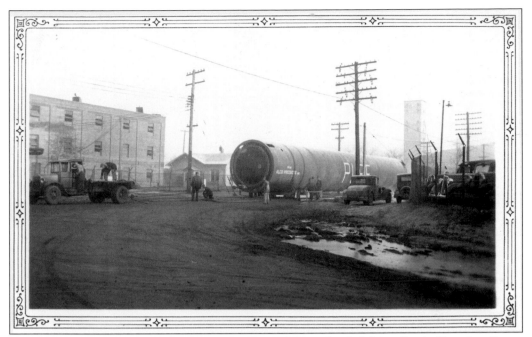

Pictured here is a new Pure Oil Company smokestack being hauled down South Cherokee Street to the company's Muskogee refinery, located at Madison and South Cherokee Streets. The large smokestack was hauled into Muskogee on a special rail car.

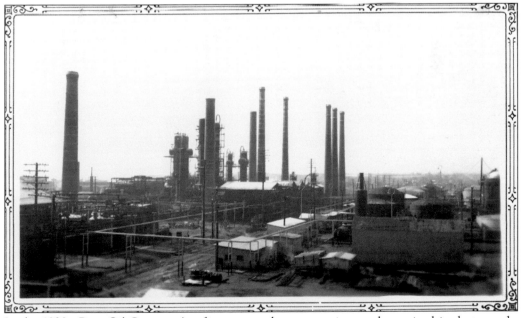

In the 1930s, Pure Oil Company's refinery was a large operation, as shown in this photograph. The company, now known as Unocal, later shut down its Muskogee refinery, and little remains of the site today.

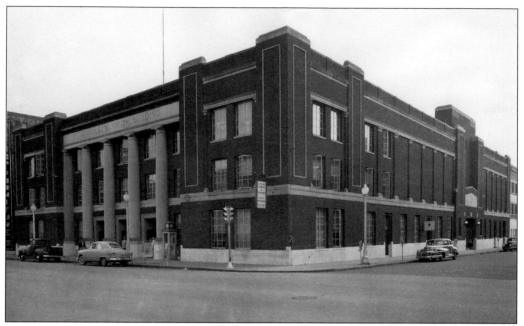

Muskogee's Municipal Building, located at 229 West Okmulgee Avenue, was dedicated on May 29, 1931, and remains the center of city government. When it opened, the building included a civic auditorium and stage, and a small city museum was once housed on the first floor.

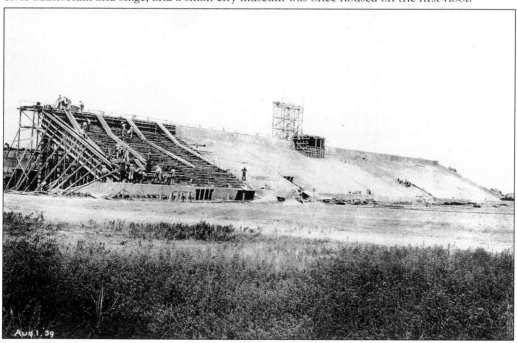

The Indian Bowl stadium is shown here during construction in 1939. The stadium replaced Athletic Park as the venue for football games and other events for Central High School and other city schools. The stadium was also used a decade later during the filming of the movie *Jim Thorpe–All American*, starring Burt Lancaster. The movie was partially filmed in Muskogee, and its premiere was held in the city.

Five

CITY ON THE HOME FRONT
1940–1949

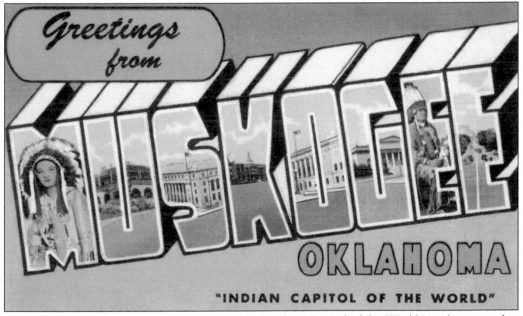

For many years, Muskogee was promoted as the "Indian Capitol of the World," as shown in this postcard image. In 1948, Muskogee celebrated its diverse Native American heritage with the Indian Centennial. Many activities and events were held in the city to honor the 100th anniversary of the arrival of the Five Civilized Tribes (Cherokee, Creek, Choctaw, Chickasaw, and Seminole) into the area. A US postage stamp was created to highlight the centennial. Today, Native American culture and history remain an important part of Muskogee, and Oklahoma still has one of the largest populations of Native Americans in the United States.

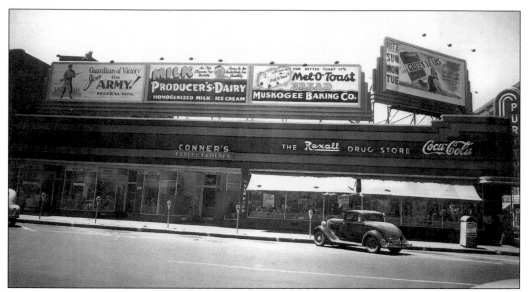

Purity Drug Store No. 5, located on the southeast corner of Third and Broadway, is shown here in 1946. Purity Drug Stores were part of a local business that eventually expanded to 10 stores located in all parts of Muskogee. Store no. 5 was extremely popular due to its central location. The stores were owned by Joseph J. Magoto, who also owned Muskogee's minor-league baseball team.

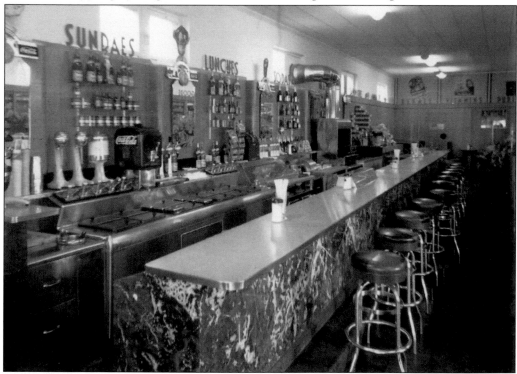

The soda fountain at Purity Drug No. 5 is shown here. The soda fountain area was a popular location to socialize over the years. This soda fountain has been identified as one from the Liquid Carbonic Company, which was a top-quality unit with the fountains lined with zinc and covered with marble.

Carnation Dairy, located at 315 East Broadway, was another popular spot in Muskogee in the 1940s and 1950s. The building still stands today, but has not been used for many years.

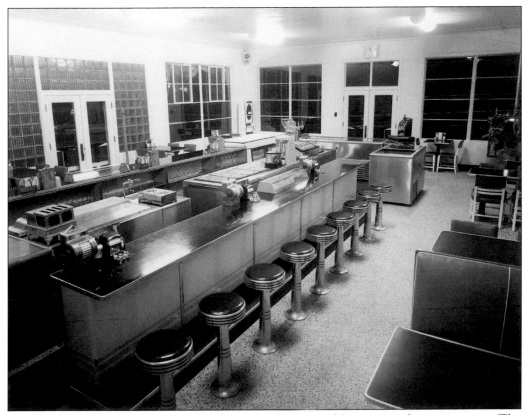

This image shows the interior of the Carnation Dairy retail business without customers. The business typically filled with customers soon after it opened, especially in the summer months.

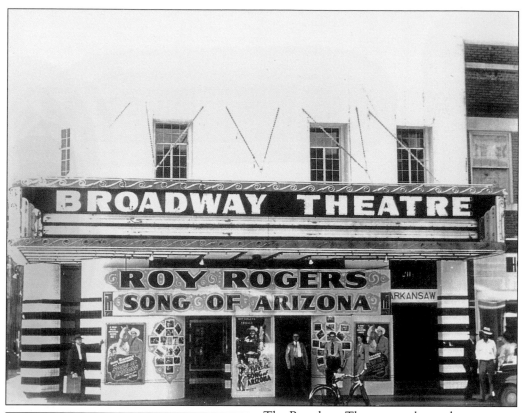

The Broadway Theatre was located at 211 West Broadway. The theater was first established in 1912 as a vaudeville house and was later converted to show motion pictures. This photo is from 1946, when Roy Rogers's *Song of Arizona* was playing. The Arkansaw sign at right refers to the adjacent Arkansaw Building, which was actually spelled this way.

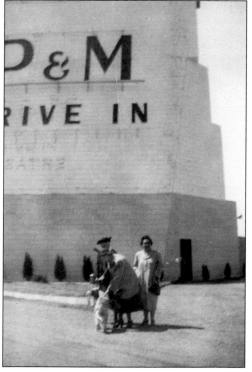

Workers from the P&M Drive-In Movie Theatre pose with a dog in front of the facility. The P&M, built in the late 1940s, was one of the theaters owned by George Proctor and Hugh Marsh and was the first drive-in movie theater in Muskogee. It was located west of town on the present-day site of Ben Franklin Elementary School.

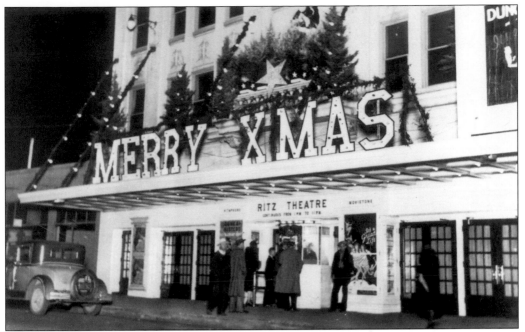

The crown jewel of theaters in Muskogee was the Ritz Theatre, which was known as the Hinton Theatre in vaudeville days. This image from 1943 shows the theater decorated for Christmas, with *It's a Great Life* playing. The movie was one of a series of films about Blondie and Dagwood, from the popular comic strip *Blondie*.

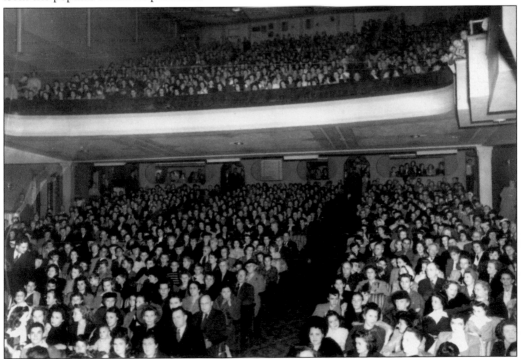

This image shows a full house at the Ritz Theatre during the 1940s. The Ritz typically ran top-tier movies and, as shown in this photograph, customers dressed up to go to the movies.

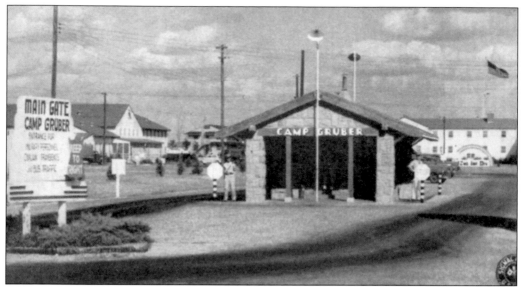

Following the outbreak of war in Europe, President Roosevelt authorized the building of several military training camps in the United States. One of them became Camp Gruber, which was built to the east of Muskogee, near Braggs. The base was named for Gen. Edmund Gruber, the author of the artillery song, "The Caissons Go Rolling Along." The entry gate is shown here shortly after the camp became operational in 1942.

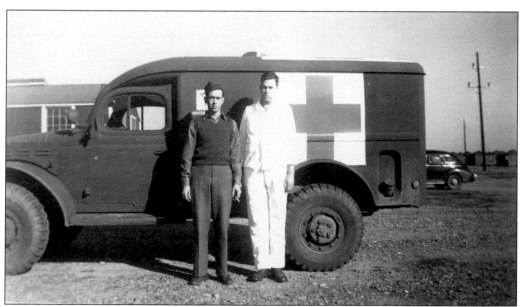

The opening of Camp Gruber brought an influx of soldiers from across the United States. The camp provided training to infantry, field artillery, and tank destroyer units that went on to fight in Europe. The base also was used as a prisoner of war camp, and about 3,000 German prisoners were incarcerated there. This photograph shows an ambulance unit in the POW camp.

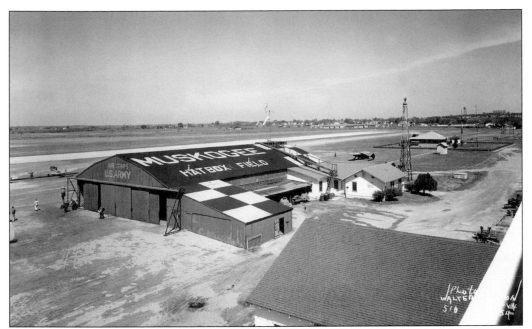

In addition to the military activity at Camp Gruber, Tulsa's Spartan Aviation School built an airbase facility at Hatbox Field in Muskogee in 29 days in 1940. At the time, they added barracks, classrooms, a cafeteria, and an additional hangar. Within a year, a gymnasium, a hospital, a locker facility, and a parachute room were also added. This photograph shows the main hangar and surrounding operation.

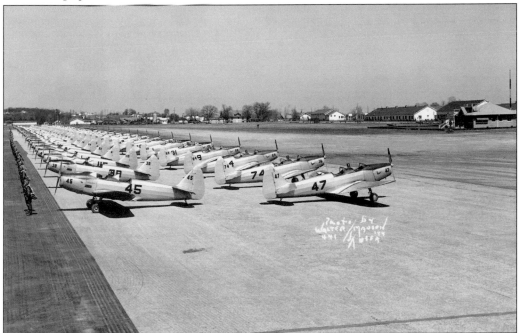

Cadets and two rows of Fairchild PT-19 Cornell trainer planes are shown "under review" at Hatbox Field in this photograph. Approximately 4,000 cadets passed through the school, which closed in Muskogee in 1944.

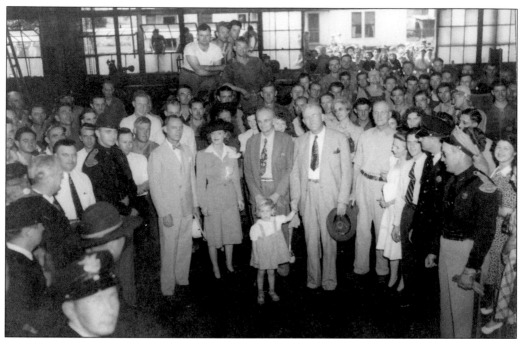

Movie star Bette Davis came to Muskogee in September 1942 to promote the purchase of war bonds. She appeared at the Ritz Theatre for a program, with the admission price being the purchase of a war bond. She then went to the Muskogee Iron Works plant, where employees had formed the first all-employee 10 percent bond club in the city. This photograph shows Davis amongst the employees and managers at the plant.

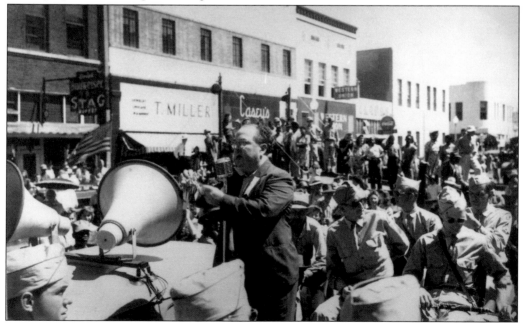

War bonds were also promoted in other ways. The chairman of the war bond efforts in Muskogee was Hugh Marsh (partial owner of the Proctor and Marsh movie houses). Here, Marsh is promoting the purchase of war bonds outside the Broadway Theatre with a group of soldiers.

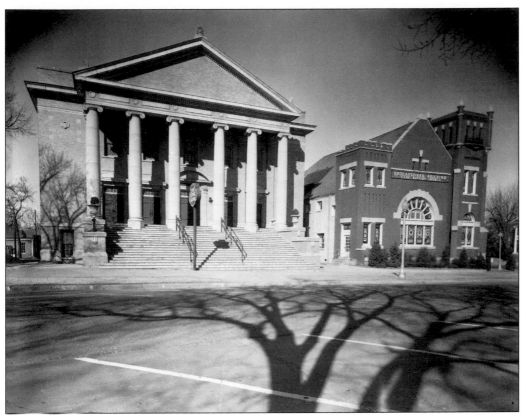

This 1940s photograph shows the First Baptist Church of Muskogee, located at Seventh Street and Okmulgee Avenue. The building on the left is the main sanctuary, which was first used by the church in 1923. The building on the right was a previous sanctuary and was first used in 1905. At this time, the older sanctuary had been converted to an education building but was later razed when a new education wing was built.

First Presbyterian Church, located at 508 West Broadway, is shown here in the 1940s. This building housed the church from 1904 until 1973, when it was replaced with a more modern structure. The church's history goes back to 1875, when it was the first church established in Muskogee.

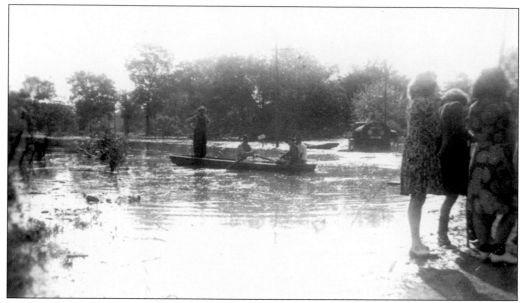

In May 1943, almost a week of continual rainfall in the area caused major flooding on the Arkansas River. On May 22 the river crested at over 48 feet, with flood stage being at 28 feet. The river went over the western bank and reached almost all the way to Fort Gibson. Soldiers from Camp Gruber were called out to help in rescue efforts. This image shows the floodwaters in the Hyde Park area.

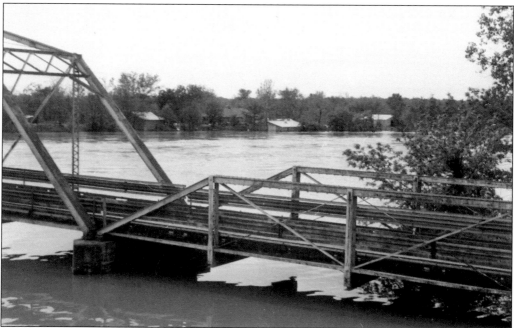

Travel became almost impossible during the flood, as most of the bridges and low spots in the area were underwater. Soldiers on leave from Camp Gruber for a weekend were unable to get back across the river to camp. This image shows one of the railroad bridges across the Arkansas River during the flood. The flood did major damage to crops and livestock, and several people drowned in the floodwaters.

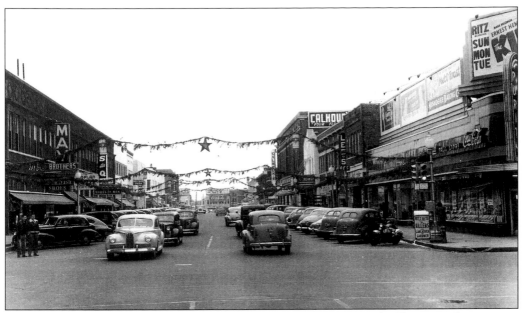

This photograph from 1946 depicts an active downtown scene, with Christmas decorations stretched across the street. The picture was taken from Third Street, looking east. Purity Drug No. 5 is seen on the immediate right, with Calhoun's Department Store farther down. On the left, May Brothers Department Store and S&Q Clothiers can be seen.

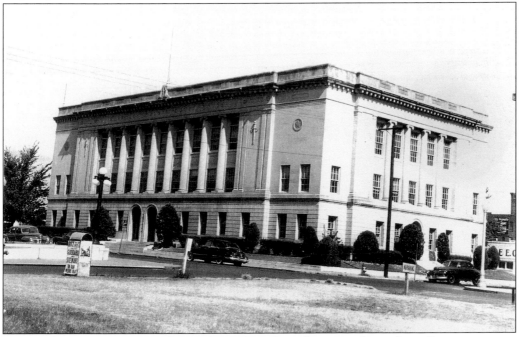

The Muskogee County Courthouse, located on State Street, is shown here. For many years, Muskogee's courthouse moved from building to building. In 1927, a bond issue was passed and plans to build a permanent courthouse building were finalized. The movie advertisement in front dates this image from around 1948. Evidently, Old Glory was not waving at the courthouse on this day.

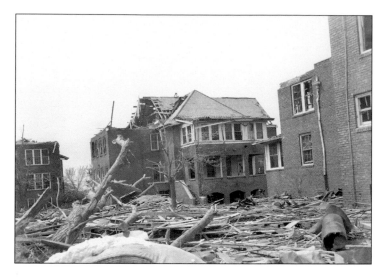

On April 12, 1945, most people in the United States were listening to radio reports about the death of Pres. Franklin D. Roosevelt. Muskogee, though, suffered a deadly tornado that afternoon, which killed three students at the Oklahoma School for the Blind and injured many others in the community. This image shows the aftermath of the storm at the school.

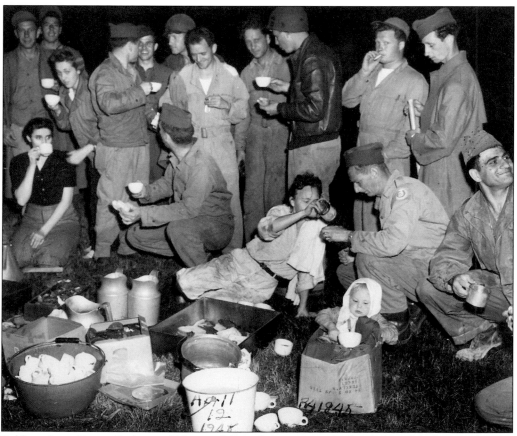

Soldiers from Camp Gruber and National Guardsmen were called to help in Muskogee after the storm. This photograph shows soldiers at the school taking a break with teachers and students of the Oklahoma School for the Blind.

The tornado also did severe damage to the Hyde Park area of Muskogee, near the Arkansas River. With little warning, the tornado moved through the area and destroyed the canning factory, as shown in this aerial photograph taken a few days after the tornado. Many homes and other buildings were destroyed or heavily damaged.

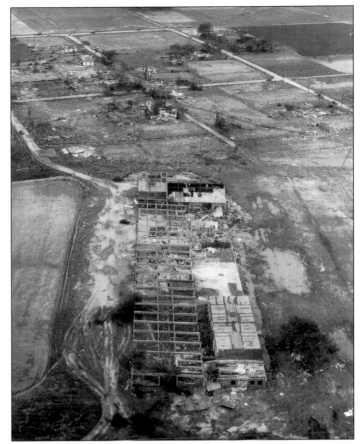

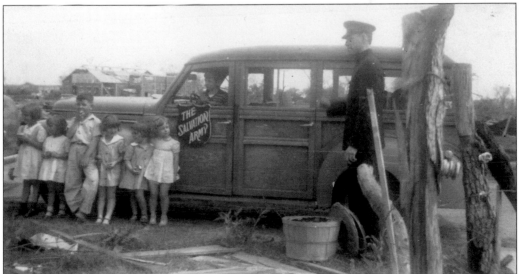

This photograph, taken on April 21, 1945, at Hyde Park in the aftermath of the storm, shows Captain Fulton of the Salvation Army with children from the area. Fulton brought the children a basket of apples and is letting one of them pretend to drive his vehicle. (Courtesy of Henry and Joyce Dye.)

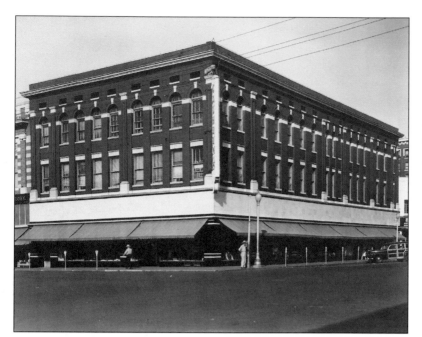

Calhoun's Department Store (or Dry Goods) was popular for many years. The business was located at 201 West Broadway. This photograph shows the business in the 1940s.

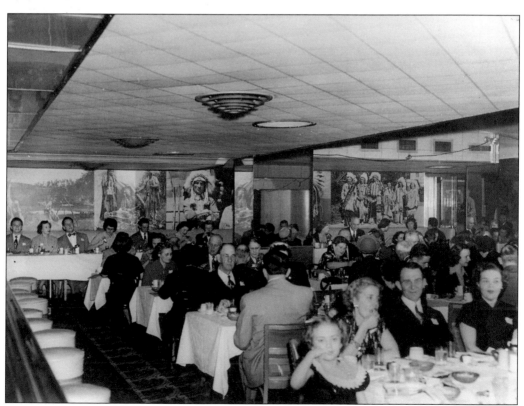

The Pioneer Room at the Severs Hotel is shown here in the midst of a formal event. For many years, the hotel was the primary location for banquets and club meetings. The Chamber of Commerce, Kiwanis Club, Lions Club, and Rotary Club all met weekly in the hotel.

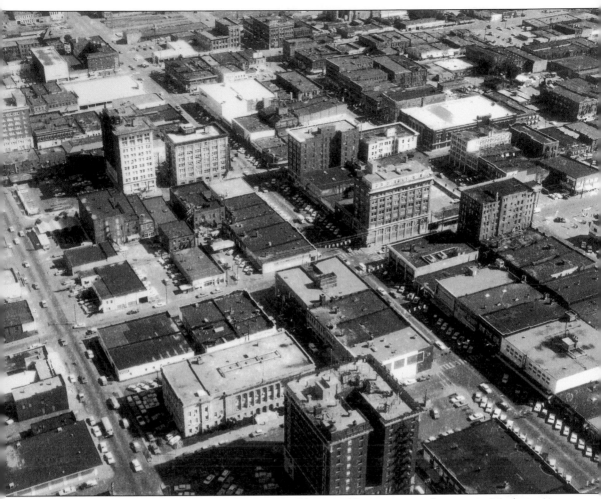

This aerial view from the 1940s shows the many buildings and large amount of activity in Muskogee's core downtown area at the time. The photograph was taken while flying near the Severs Hotel building (shown at bottom center) and is looking east. Many of the buildings pictured here no longer exist.

In October 1948, Muskogee celebrated the Indian Centennial with numerous activities and events. The celebration commemorated the 100th year of the Five Civilized Tribes in Oklahoma. The official seals of the Five Civilized Tribes were painted on Third Street by artists. Seen here are contestants of the Pioneer Costume Contest posing at Athletic Park. Ruth Hurst, second from right, was named the winner and received $25.

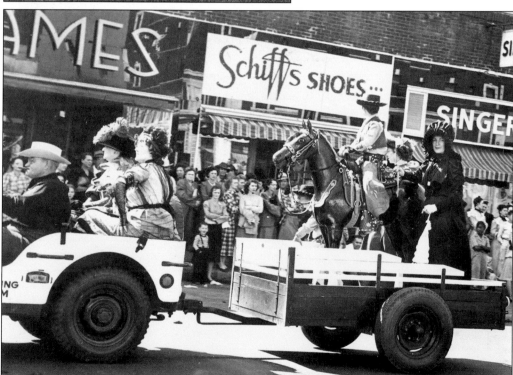

A large parade was held during the Indian Centennial festivities. In this photograph, costume contest winner Ruth Hurst is shown being towed on a trailer in the parade down Broadway, along with one of her children.

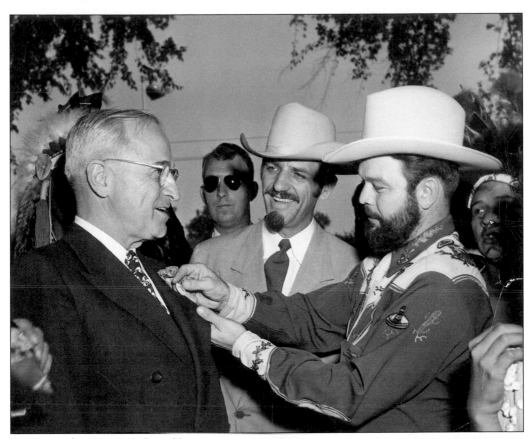

On September 29, 1948, Pres. Harry Truman made a campaign stop in Muskogee and gave a speech in the bandstand in Spaulding Park. In this photograph, President Truman is being given a mock "shave permit," as many town boosters were growing beards for the Indian Centennial celebration. Pictured with Truman are Dick Micowski (with goatee) and Bob Hurst (pinning permit). This photograph appeared in the *New York Daily News*.

This boy enjoys activities at the Muskogee Free State Fair in the 1940s. The Muskogee Fair was one of the most-attended events in the area.

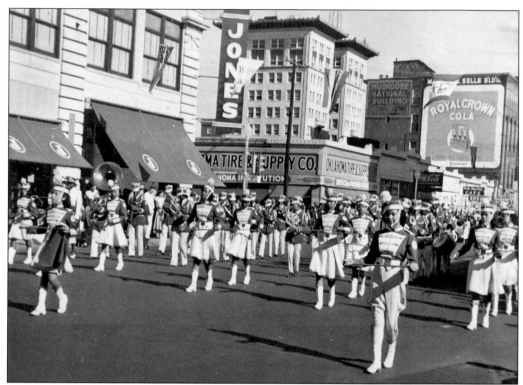

Manual Training High School's marching band is shown here marching down Broadway between Fourth and Fifth Streets. Manual's band was always highly sought out for parades and other events due to its precise marching skills, musical ability, and visual presentation. Aaron Bell, who later became a world-class jazz musician, directed the band from the 1940s up until 1947, when Avalon Reece took over as director.

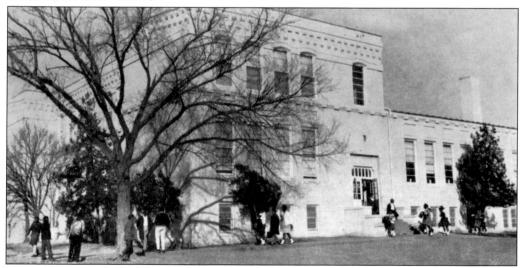

Manual Training High School is shown here in the 1940s. The school was originally located at 620 Altamont and was the African American school in Muskogee during the days of segregation. The original building had 19 classrooms for grades six through 12. Many Manual High School graduates went on to become leaders in business, education, medicine, and entertainment.

The Brockway Glass plant is shown here under construction in 1945. The business was later bought by Owens-Illinois and continues to operate today in the same location, at the intersection of York Street and Shawnee Boulevard.

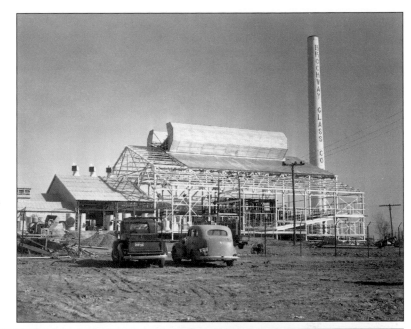

The Corning Glass plant opened in Muskogee in 1948. This photograph was taken during an open-house tour of the business in the first year of operation. The Corning Glass plant manufactured items such as Pyrex measuring cups, Coleman lantern globes, and Mr. Coffee pitchers. Corning Glass Works closed its Muskogee plant in June 1987 after 39 years in business.

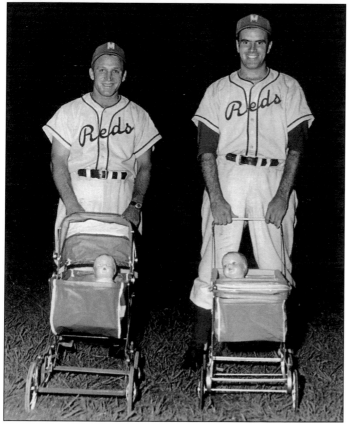

The 1949 photograph above shows a minor-league baseball game at Muskogee's Athletic Park. At the time, the Muskogee Reds were a farm team of the major-league Cincinnati Reds. Muskogee had nine different minor-league teams over 46 seasons. None of these teams were successful in winning a championship, but many players made it to the majors, including Hall of Fame catcher Bill Dickey.

The image at left, from 1949, shows Muskogee Reds Heine Mueller (left) and Buck Ross during a promotional night at the ballpark. Mueller was a player-manager for the team and was a former St. Louis Cardinals outfielder. Ross was a longtime Muskogee player and became a permanent resident of Muskogee.

Six
OKIES FROM MUSKOGEE
1950–1979

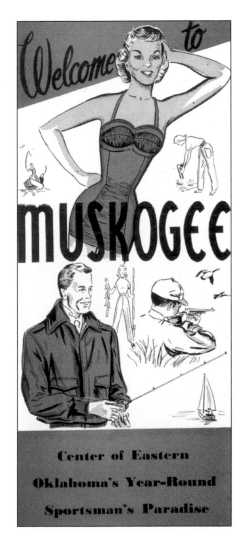

With the completion of construction on nearby Fort Gibson Lake, Tenkiller Lake, and Greenleaf Lake in the late 1940s, Muskogee soon became a popular site for water-related activities. The city (which then had a population of about 37,000) soon began to promote itself as a tourist destination, calling itself the "Water Capitol of the Southwest." This image shows the cover of an early 1950s promotional brochure that highlighted the recreational activities available in the area and invited visitors to make Muskogee their recreational headquarters. The inside of the brochure further stated that, "there is more RECREATION and more HISTORY at or within a 30 minutes drive from Muskogee than in any area in Oklahoma."

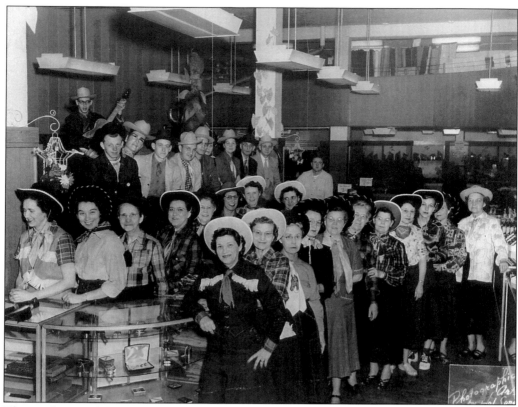

The employees of Hunt's Department Store in Muskogee are shown here during "Western Days." Hunt's was a popular store for many years and was located at 305-307 West Broadway.

The exterior of Hunt's Department Store is shown here in the 1950s, before renovations to the exterior were completed. The business operated in Muskogee until the mid-1980s. Hunt's signs still remain on the building today.

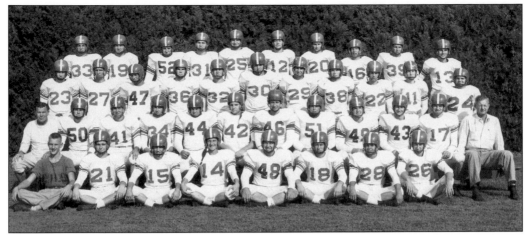

In 1999, at the end of the 20th century, the *Tulsa World* newspaper named the 1950 Muskogee Roughers high school football team as Oklahoma's "Team of the Century." The team finished the season 13-0 and won the state championship. They were coached by legendary coach Paul Young and had four future University of Oklahoma stars—Max Boydston, Kurt Burris, Bob Burris, and Virgil "Bo" Bolinger.

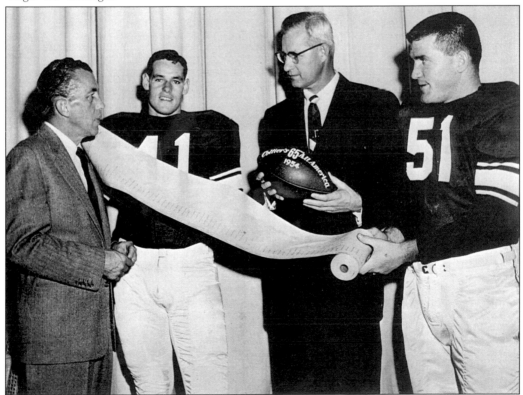

In November 1954, Muskogee football coach Paul Young (holding football) and two former players, Max Boydston (second from left) and Kurt Burris (far right), appeared on Ed Sullivan's *Toast of the Town* television show. The two players were the first players from the same high school and college to be named All Americans. Boydston and Burris are holding a lengthy telegram—with over 6,000 signatures—that Muskogee residents sent to the show.

Every Day's
GREAT
on Channel 8

SUNDAY:
　　5:45 Reddy's News Hound
　　　　　and Weatherbird
　　9:30 Favorite Story

MONDAY:
　　7:00 Pee Wee King Show
　　9:00 TV Reader's Digest

TUESDAY:
　　7:00 Make Room for
　　　　　Daddy
　　9:00 The Falcon

WEDNESDAY:
　　6:30 Mr. Citizen
　　7:00 Disneyland
　　8:00 Wednesday Night
　　　　　Fights

THURSDAY:
　　7:30 Ponds Theatre
　　9:00 Star Tonight

FRIDAY:
　　6:30 Rin Tin Tin
　　8:30 Ozzie & Harriet

SATURDAY:
5:00 Bowling Sweepstakes
7:00 Ozark Jubilee

... and every evening at 10:30
　　there's a great film on ...

"THEATRE 8"

Channel **8**
KTVX

In 1954, Muskogee's KTVX Channel 8 television station went on the air. The first program aired by the station was the 1954 collegiate football game between the top ranked Oklahoma Sooners and the California Golden Bears. The station was owned by Muskogee businessman John T. Griffin. The station's studio was located on East Side Boulevard in Muskogee for a few years before it moved to Tulsa and became KTUL. This is a KTVX schedule from 1955.

The Muskogee Free State Fair was always a popular event for children. This image from the 1950s shows a nursery school class attending the fair and enjoying a carousel ride.

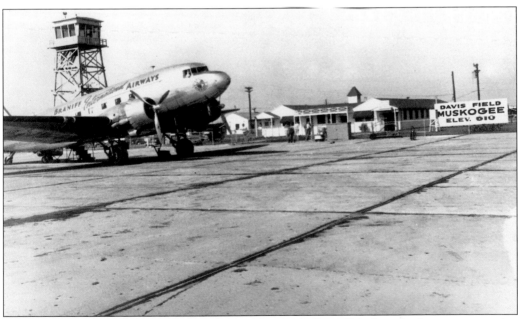

Starting in the late 1940s and for several years afterwards, Braniff Airlines had passenger service originating out of Muskogee's Davis Field Airport. This image shows a Braniff airplane being readied for takeoff at the airport.

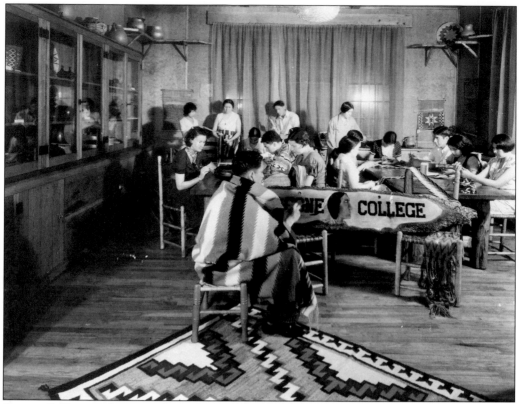

Bacone College students are shown here in the 1950s working at the Ataloa Lodge Museum on the campus of the college. The museum houses one of the country's finest small collections of Native American art and artifacts.

This 1955 photograph shows Muskogee mayor Lyman Beard (left) and city manager Clay Harrell (right) congratulating Ray Jordan on his appointment as Muskogee's fire chief.

Movie star Joel McCrea (wearing headdress) is shown here during activities surrounding the world premiere of the motion picture *The Oklahoman*, which was held in Muskogee in April 1957. This photograph appears to have been taken at the Severs Hotel.

Rockabilly music star Gene Vincent and his band, the Blue Caps, made an appearance in Muskogee in 1957. This photograph shows Vincent on stage holding a KBIX (Muskogee radio station) microphone.

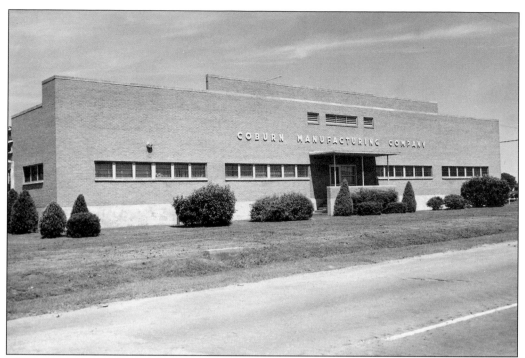

The Coburn Manufacturing building at 1701 South Cherokee Street is shown in this 1958 photograph. Under the leadership of founder O.W. Coburn and his family, Coburn Manufacturing grew to become the leading optical equipment manufacturer in the Unites States before eventually being sold.

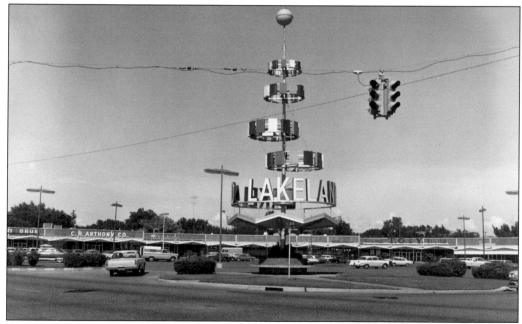

Lakeland, Muskogee's first shopping center, opened on April 11, 1957. When it opened, the parking lot was full all day and street parking was crowded for blocks. Supermarket chain Humpty Dumpty gave away orchids to the first 2,000 women who entered the store during the grand opening.

Brothers J. Howard Edmondson (left) and Ed Edmondson, of Muskogee, became important political figures in the 1950s and 1960s. Ed ran for and won a congressional seat in 1952 and continued to serve in Congress until 1973. J. Howard entered the Oklahoma gubernatorial race in 1958 as a virtually unknown candidate and won the election with an innovative campaign and creative television advertisements. J. Howard was only 33 years old at the time of his election.

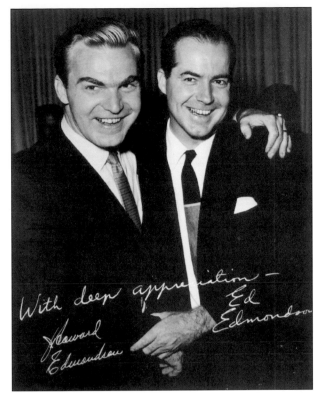

From left to right, Maj. Gen. William Fox Cassidy, Sen. Robert S. Kerr, and Quincey Sandus are shown here at the ground-breaking ceremonies for the Port of Muskogee in September 1962. Kerr and other Oklahoma legislators worked for many years to appropriate funding for navigation on the Arkansas River. The port remains an important part of Muskogee's economy.

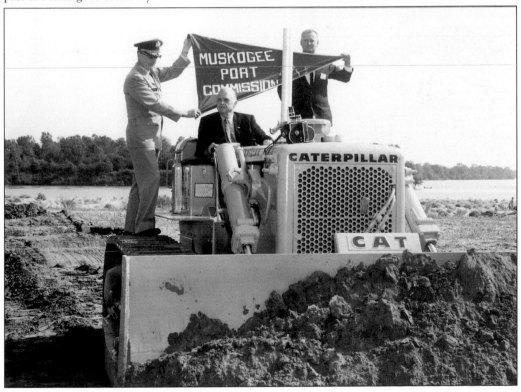

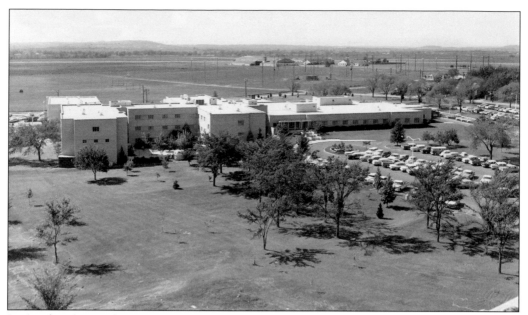

In April 1956, Muskogee citizens voted for the establishment of a new hospital, to be located near Hatbox Field. The Muskogee General Hospital replaced an aging facility near Spaulding Park that had been in use since 1928. Construction on the new hospital began in August 1957 and the hospital was formally opened on April 4, 1959. This photograph shows the hospital in the early 1960s.

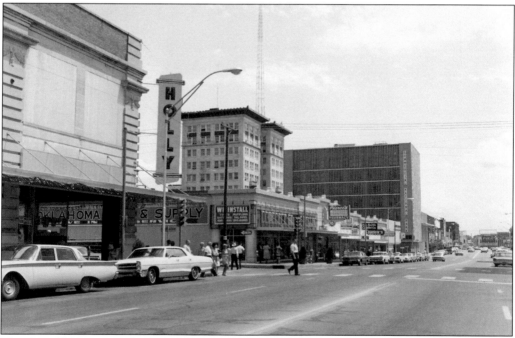

This late 1960s image shows Muskogee's downtown area, which was still the center of retail activity at this time. The Barnes Building is in the center, with the KBIX radio tower on top. Behind it is the Flynn-Ames building, which had been remodeled, with aluminum siding added to the building.

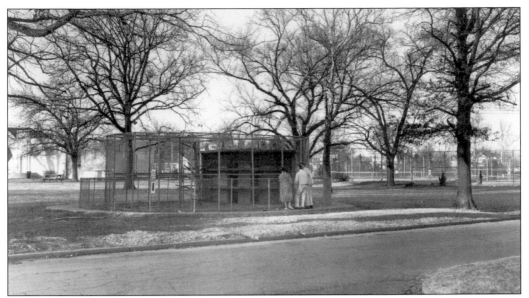

The monkey cage in Spaulding Park is fondly remembered by a generation of Muskogee citizens. This image from the 1960s also shows a portion of the former band shell that was used for concerts and programs in the park.

In this 1965 image, the West family of Muskogee feeds the ducks in Honor Heights Park. A few years later, in 1968, the park hosted the first Azalea Festival—an event that continues to bring visitors to the community each April. Art Johnson, a landscape architect and director of the Muskogee parks from 1949 to 1977, introduced mass plantings of azaleas into the park during the 1950s.

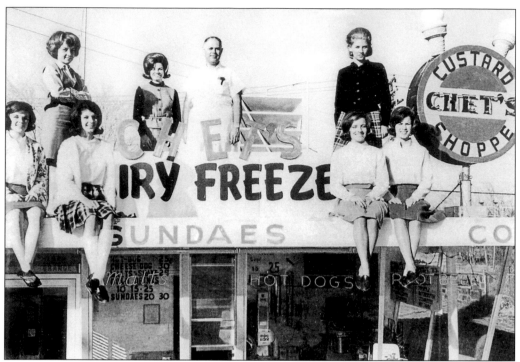

The Muskogee Central High School cheerleaders of 1964, along with owner E.C. Gilmore, pose on top of the Chet's Dairy Freeze at 3510 West Okmulgee Street. It was an annual tradition for the cheerleaders to take a picture at the restaurant with Gilmore. The business continues to operate today under different owners.

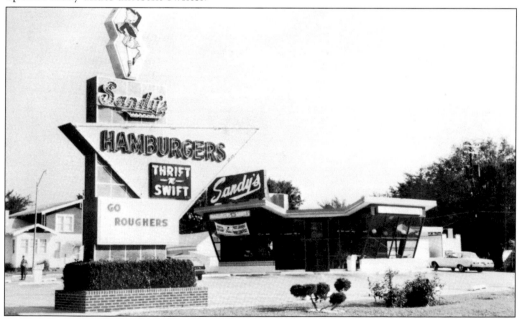

One of the first fast-food chains to come to Muskogee was Sandy's, which arrived in the early 1960s. The popular restaurant was located at 1021 West Okmulgee Street, in this unique building. Before merging with Hardee's in 1971, the Sandy's chain had as many as 121 stores in five states.

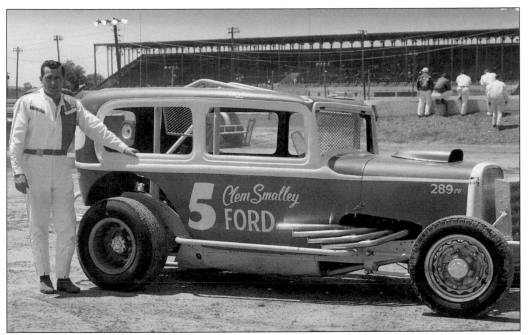

Al Lemmons and his 1932 Ford car no. 5 are pictured at Muskogee's Thunderbird Speedway in 1967. Lemmons's car was sponsored by Clem Smalley Ford of Muskogee, which was the local Ford dealership at the time.

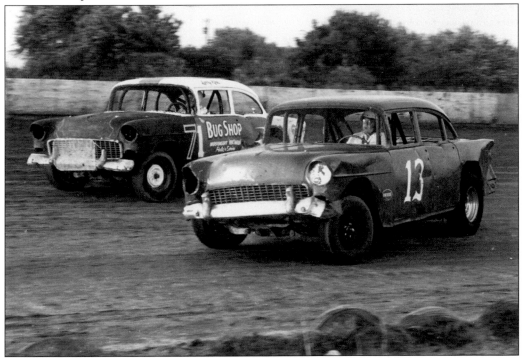

Cecil Collins (car no. 13) and Larry Ross (car no. 71) battle it out coming out of a turn at Thunderbird Speedway in 1972. Collins went on to win the race. Going to the races at Thunderbird Speedway was a popular activity, and the track recently reopened for racing.

The Civic Assembly Center was dedicated on January 14, 1968. The multipurpose facility was built to provide a space for concerts, sporting events, conventions, and other such activities. Muskogee's Central High School band was the first group to perform in the facility during the dedication event.

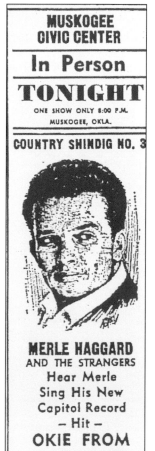

MUSKOGEE CIVIC CENTER

In Person

TONIGHT

ONE SHOW ONLY 8:00 P.M.
MUSKOGEE, OKLA.

COUNTRY SHINDIG NO. 3

MERLE HAGGARD
AND THE STRANGERS
Hear Merle
Sing His New
Capitol Record
– Hit –
OKIE FROM MUSKOGEE

Muskogee was thrust onto the world stage in 1969 with the release of country music star Merle Haggard's song "Okie from Muskogee." The song, which was co-written by Oklahoma's own Eddie Burris, was written in about 15 minutes while Haggard's band was on a bus ride through Oklahoma and read a sign along the highway that read "Muskogee 17 miles." In October 1969, Haggard gave a concert, in which the song was featured, at Muskogee's newly opened civic center. The concert was recorded and released as a live album; in 1969, it was named "Album of the Year" by the Academy of Country Music. The song was actually written as a satire, but has remained popular over the years. Country Music Television has named the song the top city song of all time. Today, people still come to Muskogee to see Old Glory waving at the Courthouse.

Muskogee's modern Central High School (right) and Fine Arts Auditorium (left) were only a few years old when this photograph was taken in 1969. The school integrated with Manual Training High School in 1970 and became Muskogee High School.

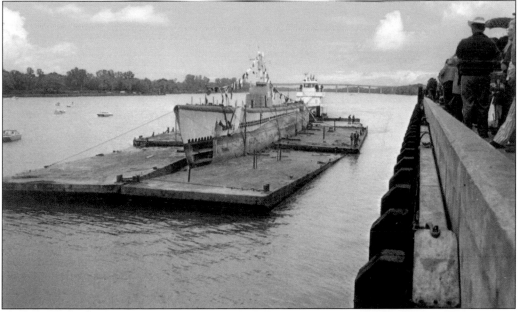

This photograph from May 7, 1972, shows the USS *Batfish* submarine arriving in Muskogee by barge. The submarine was procured from the Navy in 1971 and, after months of planning, arrived in Muskogee to become a war memorial. The Muskogee City-County Trust Port Authority donated five acres of waterfront property for the site. The *Batfish* was one of the most highly decorated submarines in World War II.

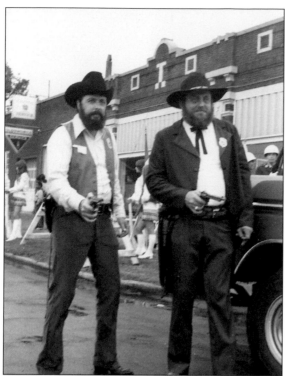

In 1972, Muskogee celebrated the 100th anniversary of its formation. This image is from the anniversary parade on October 14, 1972, and shows two "territorial marshals" having fun during the activities.

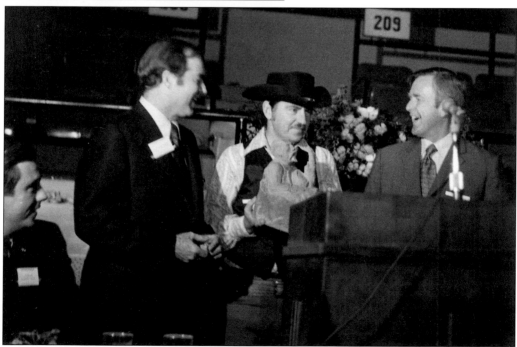

Muskogee's Clu Gulager, a television and movie star, is given a special gift during his appearance at the 100th-anniversary founders' banquet at Muskogee's Civic Assembly Center. Gulager was a veteran television actor and was well known for his roles in NBC's *The Tall Man* and *The Virginian*.

Santa Claus is shown coming down from the roof of Lakeland Shopping Center's Humpty Dumpty supermarket in the early 1970s. Santa had previously arrived by helicopter. This promotion was an annual event for several years and was popular with area children.

Muskogee's original Boom-A-Rang Diner, located at 828 East Side Boulevard, is shown here in 1973. In recent years, the Boom-A-Rang name has returned to this restaurant and others throughout a chain of over 30 restaurants in Oklahoma and Arkansas.

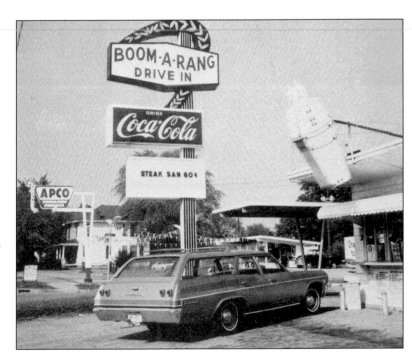

Around 1957, Alonzo "Slick" Smith rented a small building at Twenty-fourth Street and Shawnee and moved his barbecue restaurant business to Muskogee from nearby Taft, Oklahoma. After several years of operations in Muskogee, Slick's Barbecue became one of the most well known barbecue restaurants in Oklahoma and was written up in numerous magazines. This photograph shows Slick Smith in the 1970s; he passed away in 2003.

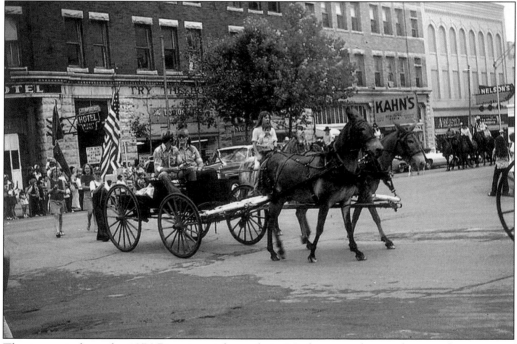

The image is from the 1976 Bicentennial parade in Muskogee and was taken on the corner of Second and West Okmulgee Streets. In the background are the Iowa Building and other businesses that were soon after destroyed in a large fire.

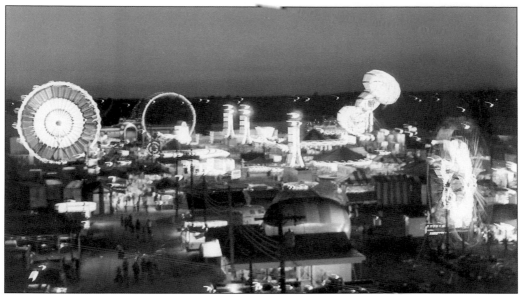

The Muskogee State Fair of 1979 is shown here at night. After many years of operation, the fair was discontinued in the 1980s. A smaller regional fair was recently established at the fairgrounds.

Honor Heights Park has been a popular recreational site for generations of Muskogee residents and visitors. The annual azalea festival held each April continues to be a leading source of tourism and activity in the community. This 1979 image shows the park's beautiful fountain surrounded by azaleas in full bloom.

BIBLIOGRAPHY

Faulk, Odie B. *Muskogee City and County.* Muskogee, OK: Western Heritage Books, 1982.

Foreman, Grant. *Muskogee: The Biography of an Oklahoma Town.* Norman, OK: University of Oklahoma Press, 1948.

Gill, Ed. *Through the Years: A History of the First Baptist Church of Muskogee, Oklahoma.* Muskogee, OK: 1962.

Ledbetter, Charles. *Alliance Against the Odds: The Manual Training High School Story.* Cross Lanes, WV: D&J Publishing, 2008.

Masterson, V.V. *The KATY Railroad and the Last Frontier.* Norman, OK: University of Oklahoma Press, 1952.

Mullins, Jonita. *Glimpses of Our Past.* Kearney, NE: Morris Publishing, 2006.

Muskogee Phoenix, End of the Century edition. Muskogee, OK: 1899.

Three Rivers Historian. Journal of the Three Rivers Museum of Muskogee. Muskogee, OK: 1998-2010.

Waits, Wallace. www.muskogeehistorian.com. *Muskogee Phoenix.* Muskogee, OK: 2007–2011.

West, C.W. "Dub." *Muscogee, I.T.* Muskogee, OK: Muscogee Publishing Company, 1972.

———. *Persons and Places of Indian Territory.* Muskogee, OK: Muscogee Publishing Company, 1974.

———. *Muskogee: From Statehood to Pearl Harbor.* Muskogee, OK: Muscogee Publishing Company, 1976.

———. *Turning Back the Clock.* Muskogee, OK: Muscogee Publishing Company, 1985.

———. *Return to Glory: Captain Severs & His Hotel.* Muskogee, OK: Muscogee Publishing Company, 1988

INDEX

DISCOVER THOUSANDS OF LOCAL HISTORY BOOKS FEATURING MILLIONS OF VINTAGE IMAGES

Arcadia Publishing, the leading local history publisher in the United States, is committed to making history accessible and meaningful through publishing books that celebrate and preserve the heritage of America's people and places.

Find more books like this at
www.arcadiapublishing.com

Search for your hometown history, your old stomping grounds, and even your favorite sports team.